THE NORTHERN LIGHTS

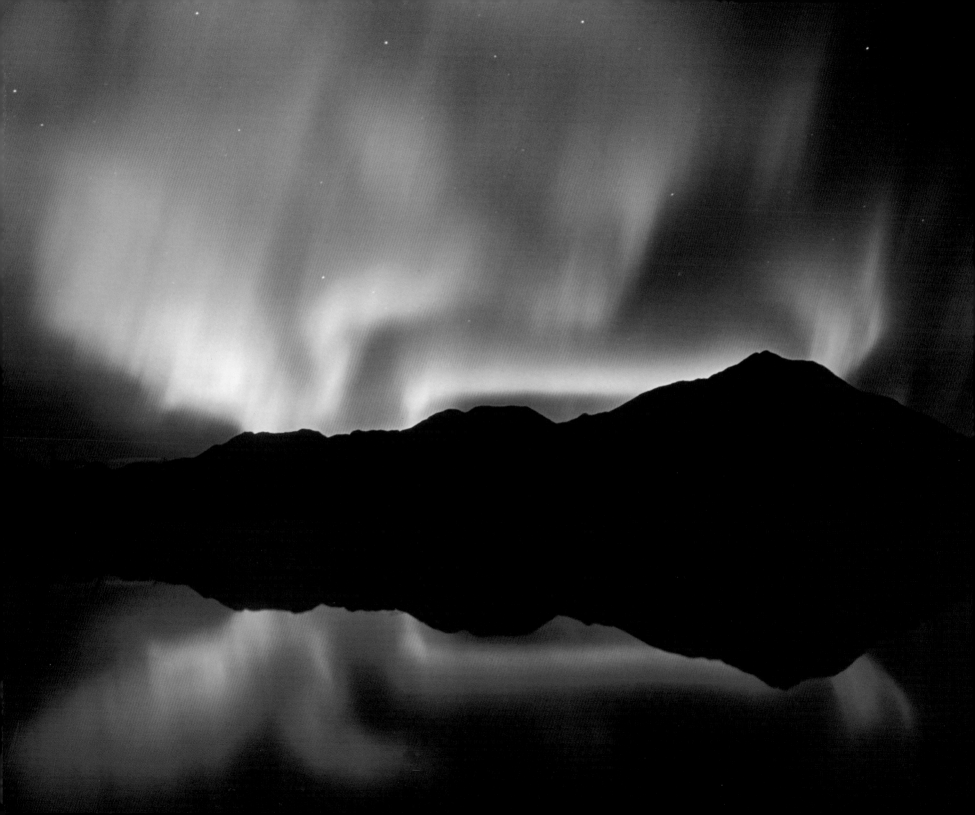

THE NORTHERN LIGHTS

Celestial Performances of the Aurora Borealis

DARYL PEDERSON *and* CALVIN HALL

Essay by Ned Rozell

SASQUATCH BOOKS

SEATTLE

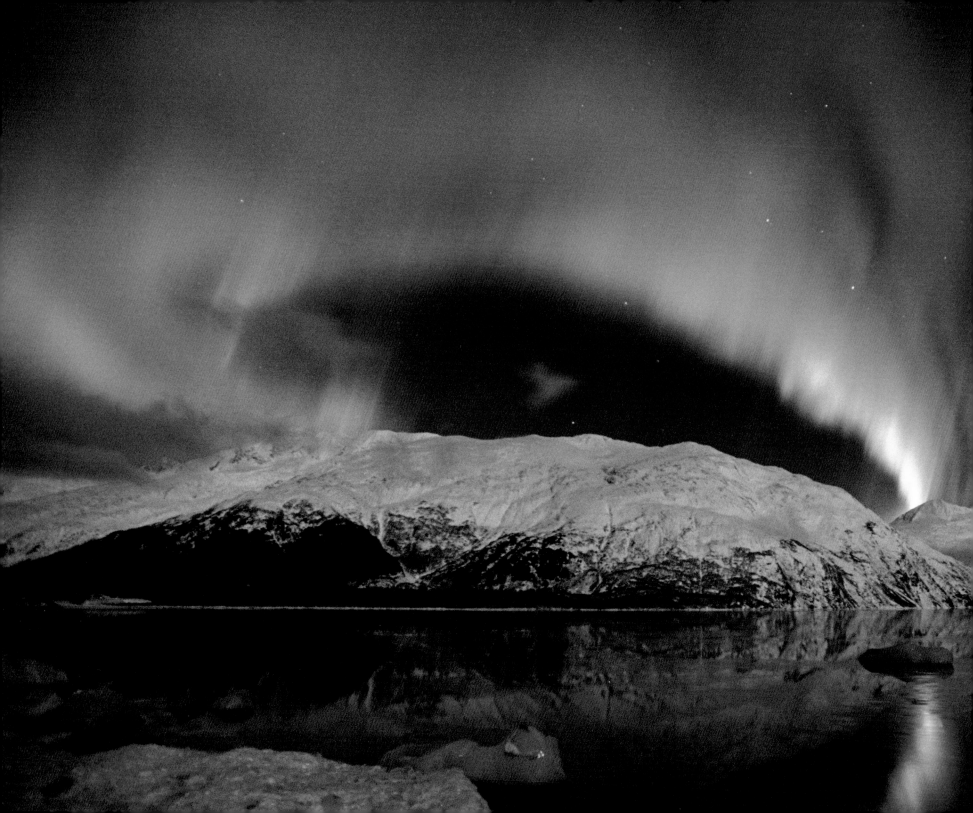

CHASING THE NORTHERN LIGHTS
by Ned Rozell

I'll tell the tale of a Northern trail, and so help me God, it's true.
I'll tell of the howling wilderness and the haggard Arctic heights,
Of a reckless vow that I made, and how I staked the Northern Lights.

—ROBERT W. SERVICE,
"The Ballad of the Northern Lights"

"Will man ever decipher the characters which the Aurora Borealis draws in fire on the dark sky?" Sophus Tromholt wrote in 1885. "Will his eye ever penetrate the mysteries of Creation which are hidden behind this dazzling drapery of color and light?"

Tromholt, a Danish teacher and physicist, was perhaps the first scientist to be paid to ponder the northern lights. More than a century after his passing, his question is still valid.

Scientists now have tools Tromholt never imagined: satellites so numerous it is difficult to glimpse a still patch of sky, Navy-surplus missiles arcing measuring devices through the auroral zone one hundred miles above our heads, low-frequency microphones that can hear the aurora's voice.

Using those instruments and others, we have learned a few basic facts about the aurora borealis. Among them that it is a gift from the sun, one that appears almost

every dark night if you live in Fort Yukon, Alaska, or somewhere else near the Arctic Circle.

Auroras appear somewhere above Earth at all times. The sun continually spews a solar wind that takes two or three days to cover the ninety-two million miles to Earth. That breath flows over marble Earth like a stream curls around a rock. As it licks the planet, the solar wind's particles react with our magnetic field, causing electric power that is the fuel of the aurora.

The aurora's most common form is a pale green halo around the northern and southern ends of the earth. That's why you can see the aurora on almost every dark, clear night in extreme northern places, and why designers of aurora observatories in Fairbanks, Alaska, face their picture windows north. The aurora has other predictable shapes, from blobs that flash on and off to the splash of corona that gives a view from directly under the curtain to the climactic substorm that explodes several times a night. Though scientists have devoted decades to the study of the aurora, some, such as Syun-Ichi Akasofu at the University of Alaska, Fairbanks, admit there remains more to learn than the sum of what we have discovered.

★

The immeasurable electrical discharge created by the solar wind's collisions with reactive atoms clinging to Earth is visible because it is close. Green auroras happen about sixty miles over our heads. As the discharge from the solar wind reacts with gases, in this case oxygen, it causes them to glow like a neon light. Akasofu, an aurora expert who was born in Japan but has lived most of his life in Fairbanks, once suggested using auroras as a detector of life on distant planets. He figures that since green and red auroras above Earth occur because plants are exhaling oxygen, auroras above other planets may be showing the same thing.

PREVIOUS PAGE: Fire and ice are becoming a rare sight as the glacier recedes from the water at Portage Lake.

RIGHT: A fiery corona aurora ushers in the new sunrise.

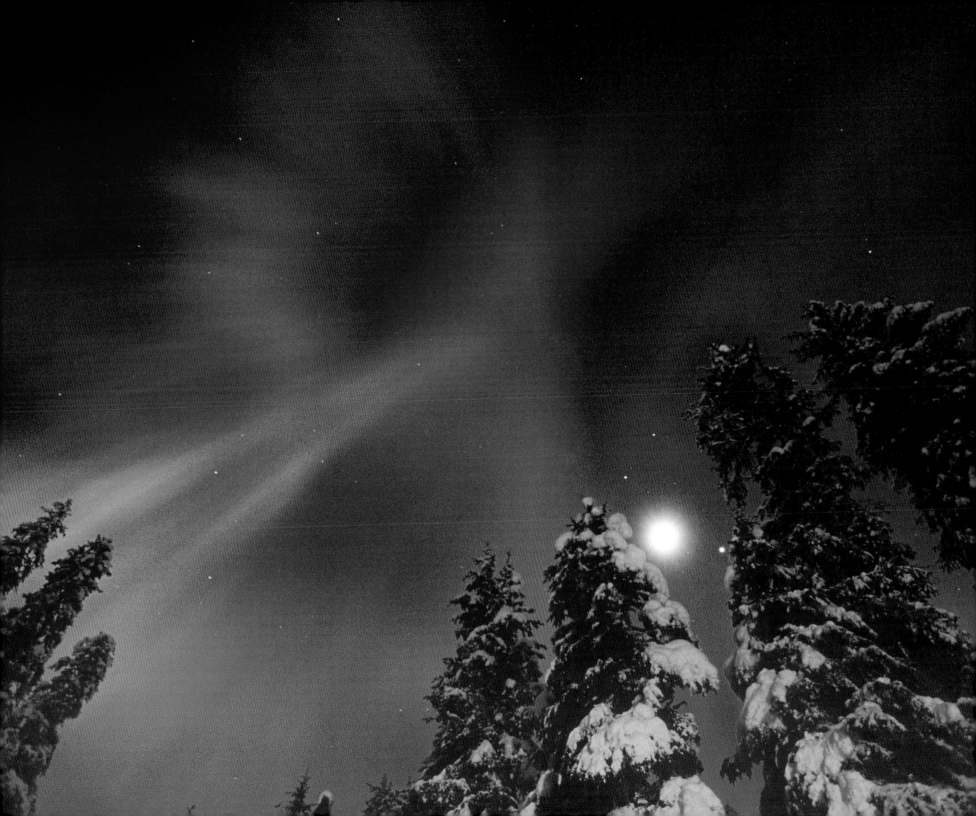

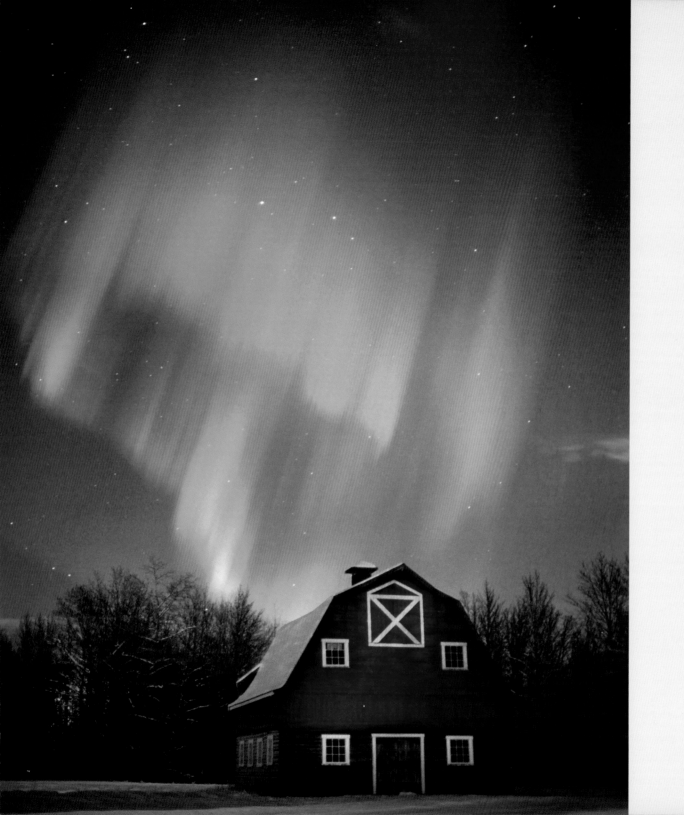

LEFT: A historical colony barn in Palmer, Alaska.

RIGHT: The Mat-Su Valley lit by bright moonlight and bands of aurora on a spectacular October night.

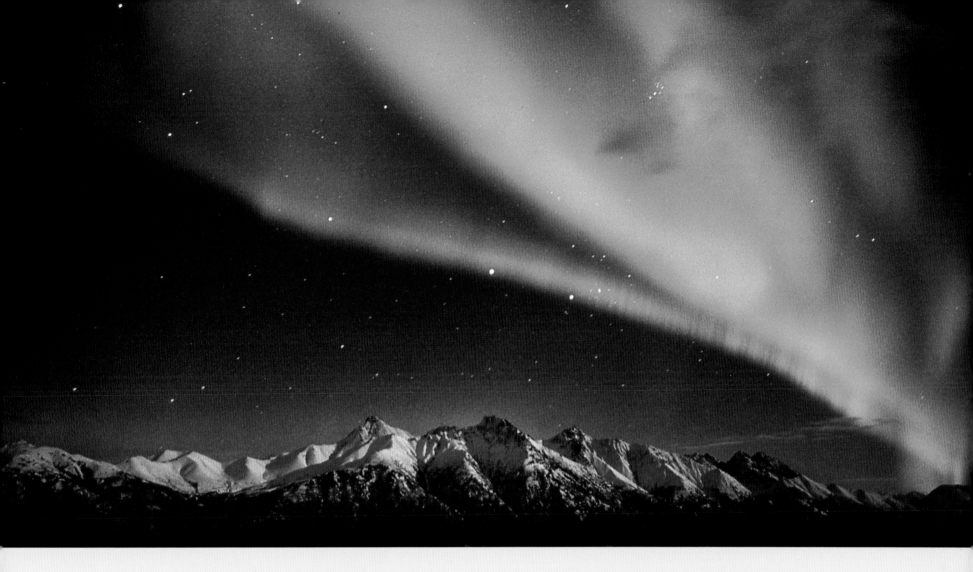

Red auroras occur much higher than the common green aurora, more than two hundred miles overhead. Red auroral displays happen so high they are the only form of aurora seen from the mid-latitudes. Many people observe tinges of red on the fringe of auroral curtains and even more cameras show them. However, the true experience, one you are lucky if you see, is a sky that is blood red.

A great red aurora is born of a solar flare—an incredible explosion on the sun—propelled in the direction of Earth by the solar wind. Red auroras are unpredictable,

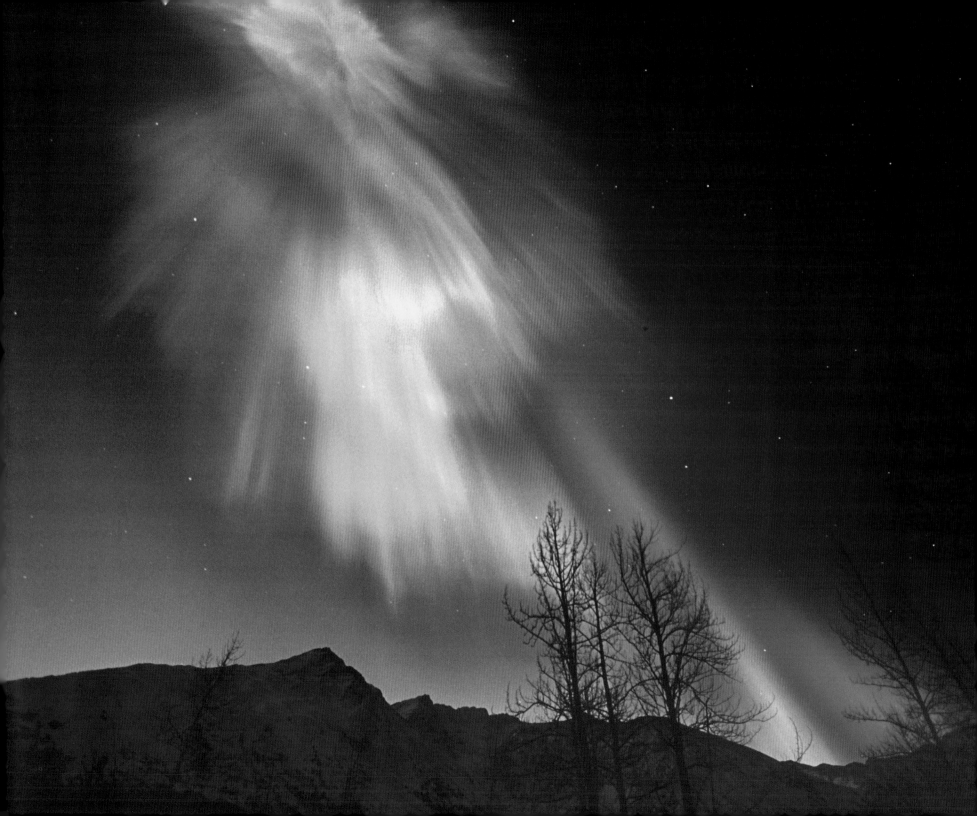

but in the past they have tended to bunch themselves around periods when the solar cycle—an eleven-year period of sun activity—features a lot of solar flares. True red auroras have happened in 1839, 1938 (seen as far south as the Sahara Desert), 1989, 2000, and—as experienced by the photographers responsible for this book—in 2001.

★

We now gain comfort in explanation, but until scientists acquired the instruments to confirm their intuitions, imagination was the rule.

The Inuit of Labrador, Canada, believed the aurora to be the light from torches of spirits illuminating a pathway to Heaven for souls of people "who have died a voluntary or violent death," according to anthropologist Ernest Hawkes, who published an account in 1916.

A story collected by Danish explorer Knud Rasmussen, during an expedition from Greenland to the Pacific from 1921 to 1924, also describes the northern lights as a pathway to the heavens: "Here, [spirits] are constantly playing ball, the Eskimos' favourite game, laughing and singing, and the ball they play with is the skull of a walrus."

★

Scientists have tried to make sense of reports of people hearing a hiss during a display but have failed to come up with an explanation. Alaska researcher, Tom Hallinan, who has heard it for himself, said his logical mind had trouble reconciling the sound with the fact that the thin air of the ionosphere—home to auroras sixty to more than two hundred miles above us—can't carry sound waves. Even if the auroras were buzzing up there, because of delays caused by the speed of sound, the hiss would require several minutes to travel to Earth. Hallinan said the voice of the aurora was "scientifically unreasonable," but the space physicist admitted he was a believer.

LEFT: Is this what the big bang looked like? A powerful solar eruption creates a long-lasting and intense geomagnetic storm.

But then, our ears are dull instruments. In the two thousand acres of woods surrounding the University of Alaska, Fairbanks, there are sensitive microphones attached to plastic tubes that fan like a spider's legs along the ground. Researchers installed a half dozen of these systems to detect the low-frequency hum of various disturbances to the atmosphere, the thirty-mile shell of gases so necessary for keeping us alive. The funding came from government agencies interested in detecting nuclear explosions from far away. The scientists found their infrasound

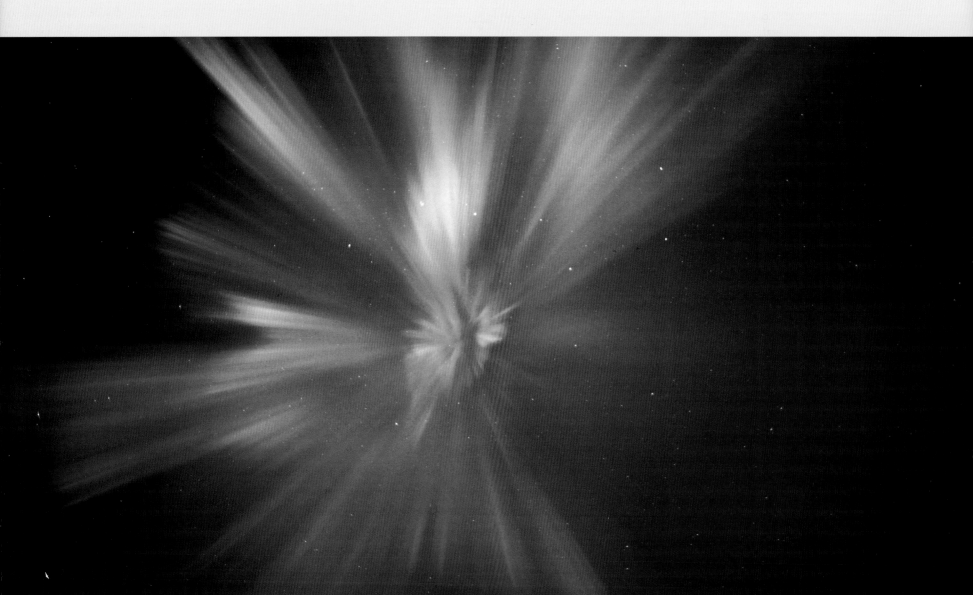

LEFT: Corona aurora photographs have the unique perspective of being shot up into the auroral curtain from underneath. Most aurora photographs show the curtain from the side perspective, usually including a foreground.

RIGHT: Ridge top Rendezvous-Matanuska Peak hosts a wild burst of early morning spring aurora.

NEXT PAGE: Before day gives way to night, an arc of northern lights can be seen above Denali and the Alaska Range.

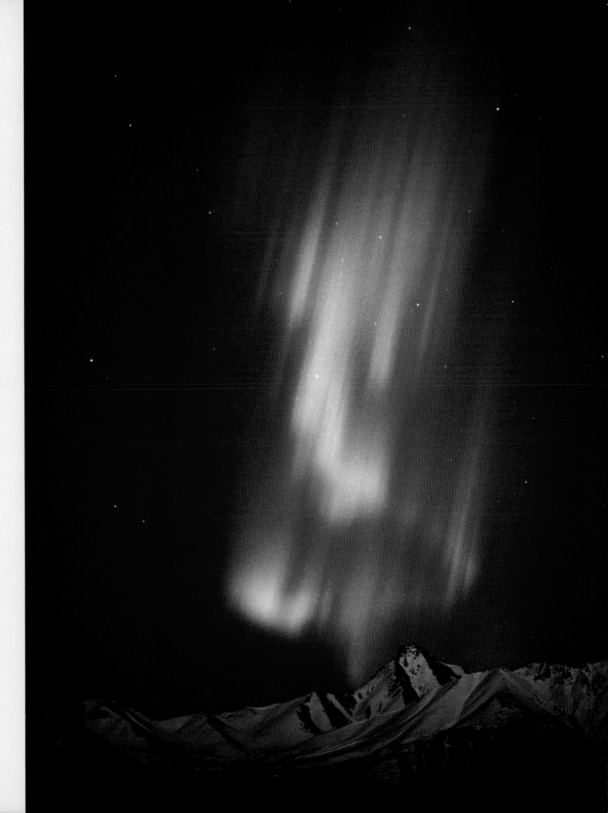

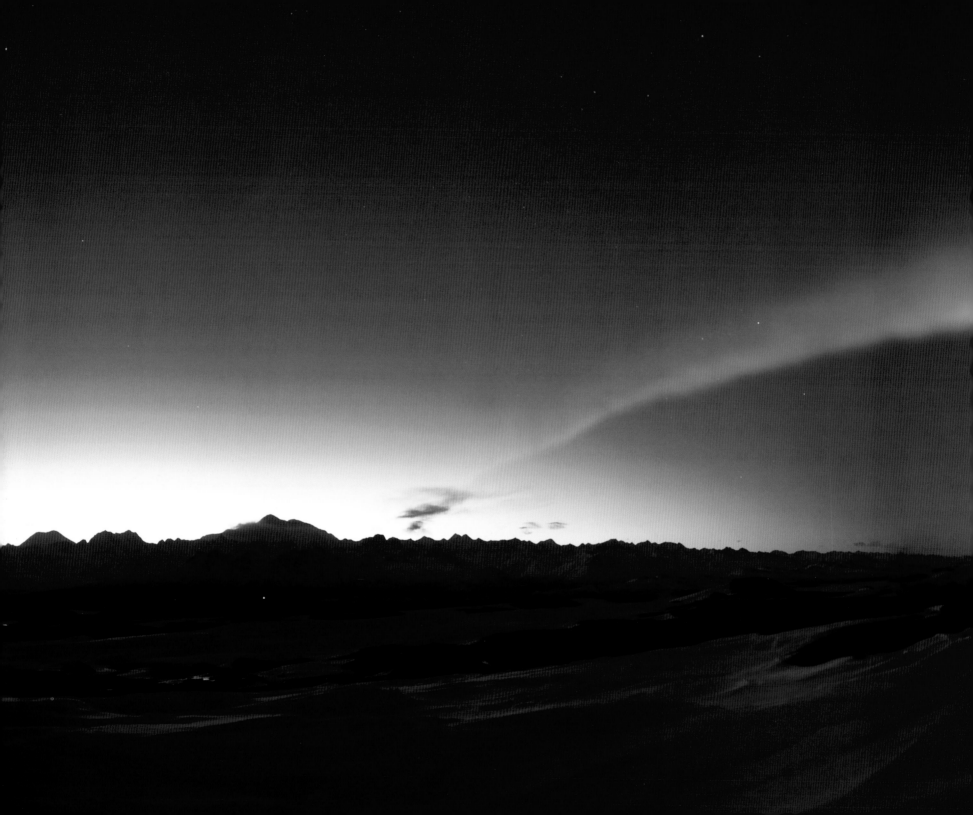

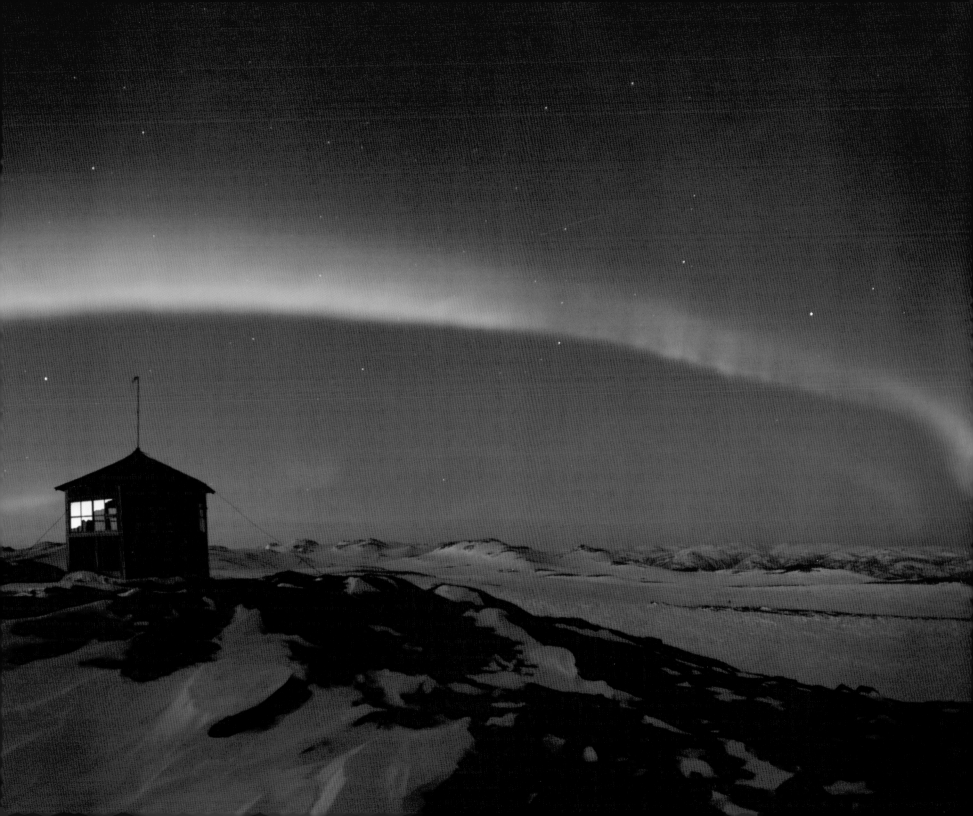

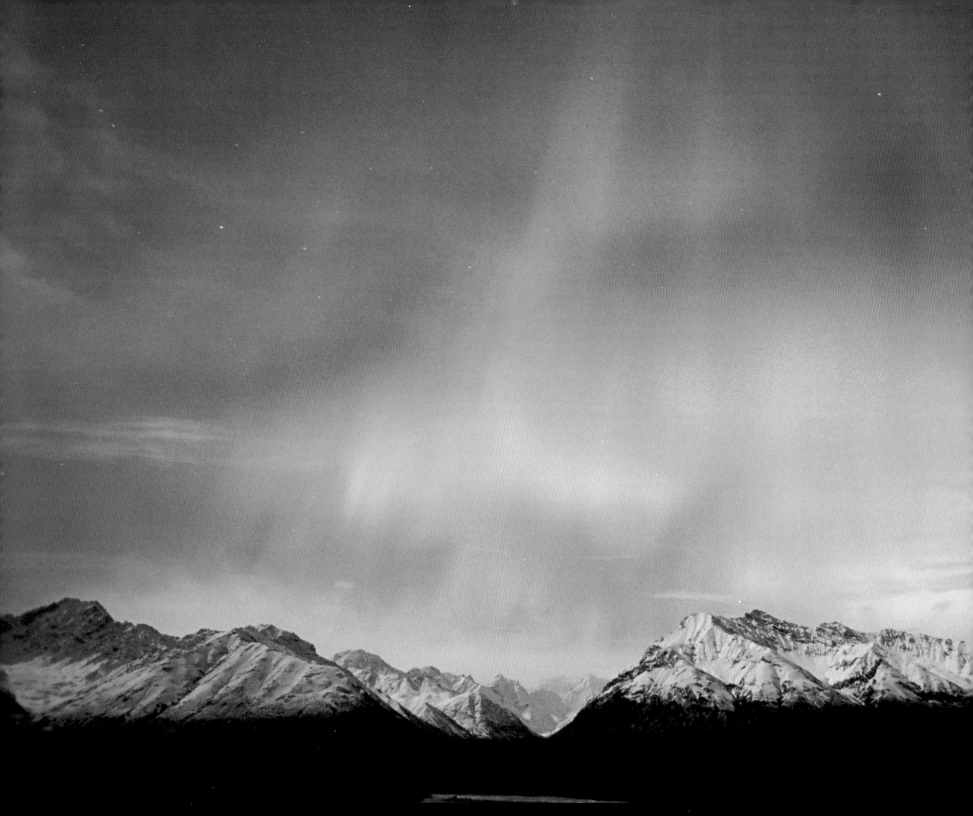

microphones recorded other things too, such as the rumble of surf in the Gulf of Alaska five hundred miles away, belches of volcanoes, and—to their surprise—electronic squiggles on a graph that correspond to a ripping aurora. So, there is proof the aurora is whispering a sound that woolly mammoths—which, like elephants, probably had the ability to hear extremely low frequencies—might have heard as they stomped the North during the last ice age.

★

Daryl Pederson and Calvin Hall know the feeling of discovery that kept the turn-of-the-century drift miner hacking at frozen gravel through the dark winter: if one keeps at it, there is always a chance a thumb-size nugget will show. In the photographers' case, if they subject themselves to enough nights of silent devotion and cold discomfort, the aurora will reward them with a spontaneous composition different from the others. Since the aurora borealis occurs most often as a halo over the North Pole, the closer one gets to the top of the world the higher the probability of photographing it—and the better chance of feeling a cold powerful enough to sap batteries and nip fingers.

Longtime residents of the zone of great aurora viewing know the price these men have paid to capture the aurora on plastic film and wafer-stored pixels. Both men's careers extend back to the days before aurora forecasts and cloud-free probabilities appeared on pocket devices.

★

Pederson remembers at first convincing a few friends to join him on frigid hilltops after he'd slugged a Red Bull at eleven o'clock at night. He had enthusiastic takers early on, but almost no one repeated the experience. Most of his aurora expeditions have been solitary endeavors, as they have been for Hall.

Although the two men have been friends sharing a unique bond over the years, they have almost never worked together. But they feel now as if they are standing

side-by-side, tripods clinging to frozen ground, as they talk on mobile phones, each sharing updates on aurora activity at his chosen location.

Daryl Pederson figures that he misses capturing a great aurora image nine out of every ten attempts. But 10 percent is pretty good, he figures, especially when the effort rewards him like it did a November night long ago. He pulled on his parka and ventured from his home in Girdwood, Alaska, late at night to see the snow glowing red. The hills reflected one of those auroras that made his heart beat as if he was a hunter hearing twigs snap at the approach of a bull moose.

Up on a hillside above Turnagain Arm, Pederson shot for an hour in a state he describes as "stunned" before clouds began obscuring his compositions. He then packed his gear and drove an arc around Cook Inlet to the tiny town of Hope, Alaska. There, he found the perfect spot. A faint moon provided definition for his foreground—snow crystals twinkling like a field of rubies. He felt the thrill of thumbing his cable shutter, knowing he was capturing something new and majestic. Looking toward the lights of Anchorage, Alaska's largest city just across Turnagain Arm, he thought of the thousands sleeping through the magic.

Hope clouded over within five minutes of his captures. Thinking of his day job that would commence in a few hours, Pederson drove home. There, he took a hot shower and pondered his magical night. As dawn lit his living room window, he by habit looked upward. There, the aurora was still active, mixing with the first scattered rays of dawn. He ran out on his deck wearing only a towel. There, he shot for twenty minutes until the morning light quenched the display. His hair had frozen into a helmet, but he had the rarest of prizes on his rolls of film, along with the delicious anticipation that accompanied the wait for development. He remembers that November night of 2001 as his "walk-off grand slam."

★

That same unusual night, Calvin Hall was also out in pursuit, a bit farther north than his friend. He remembers the hint that this evening would be different—the fog created by the vapors of an unfrozen river seemed to be glowing pink.

PREVIOUS PAGE: An aurora across the southern sky with moonlit Chugach Mountains in the foreground.

RIGHT: This was such a pleasant aurora shoot, from the warm twenty-five-degree and calm weather to a half-moon to light the foreground to open water to shoot the reflected aurora on. A rare treat for a February night!

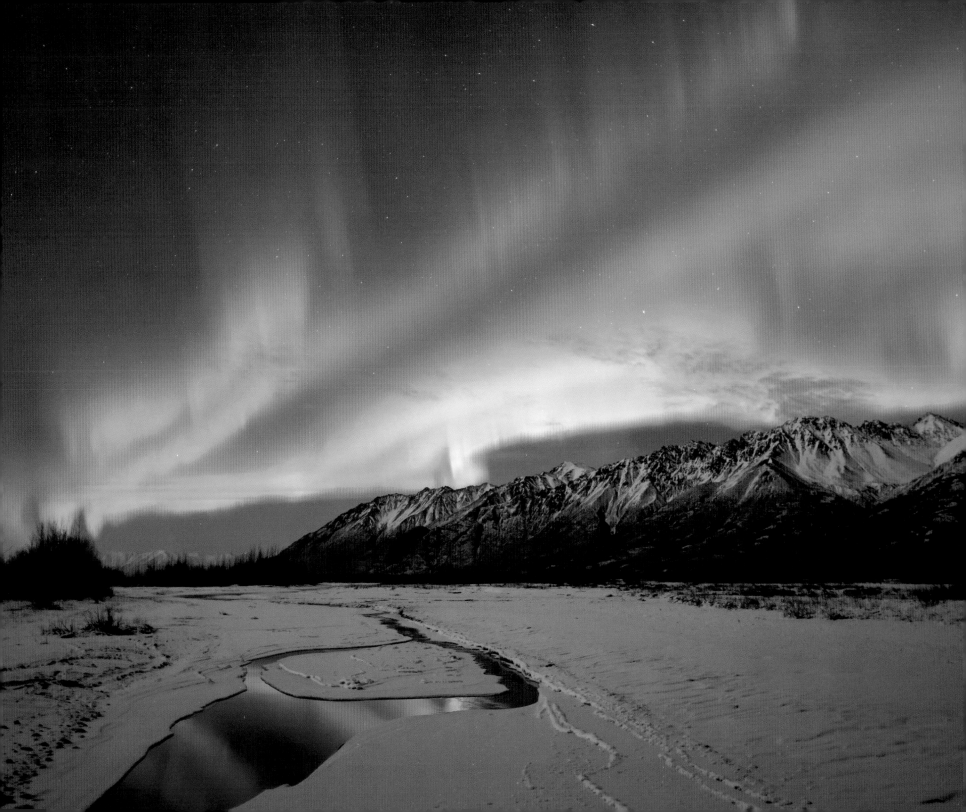

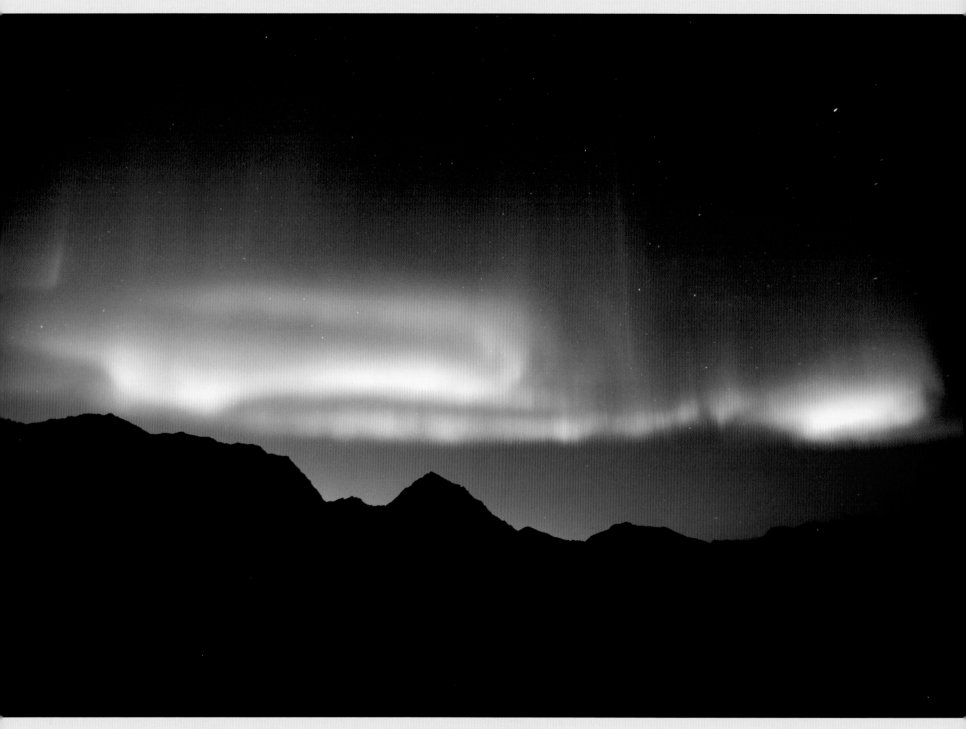

As the night progressed the red aurora revealed itself, painting the sky to a much more southern extent than more common displays. With shooting locations stored in his mind's eye, Hall remembered the Matanuska Glacier. He'd long hoped to shoot there, but it took a robust display to show itself that far southward. He knew this might be his night, so he drove to the glacier overlook on the Glenn Highway and witnessed the grand finale of the aurora night of the century.

He fired away until daylight. Like Pederson, he remembers the aurora that resulted from that solar storm as his best ever.

"The range of colors I saw in that time was the most amazing of my career. There was a partial moon, then the twilight coming in from the eastern sky, and that combination created an ever-changing sky, from rich reds and blues and greens and orange to light pastels of blues and pink and green and yellow in continually changing shapes and shades."

In addition to capturing images they might sell, both photographers have gained much more from their aurora hunting—an appreciation for the beautiful, harsh place they live and the creatures that share all those unpeopled acres.

Remembering a night he was alone on a ridgetop, Hall swears coyotes on a neighboring ridge howled just as a big auroral display flared up. As the aurora awakened at three o'clock in the morning, the coyotes sang again, this time from Hall's ridgetop.

"I could hear them take a breath between howls."

Pederson, too, appreciates the feeling of unity aurora chasing has given him. He remembers standing in his bunny boots to begin a night of patience on the shore of Cook Inlet. There, his heart skipped a beat as a beluga whale exploded a breath of fishy air into the night. The sonic eruption was perhaps fifty feet away, but seemed closer. As the aurora showed itself and he framed his composition, Pederson imagined smiling white whales sharing the black night, invisibly chasing salmon below the same surface that reflected a ballet of aquamarine light from the heavens.

LEFT: An end-of-the-season aurora on May 2 in the Talkeetna Mountains. By this time of year south-central Alaska never gets fully dark at night.

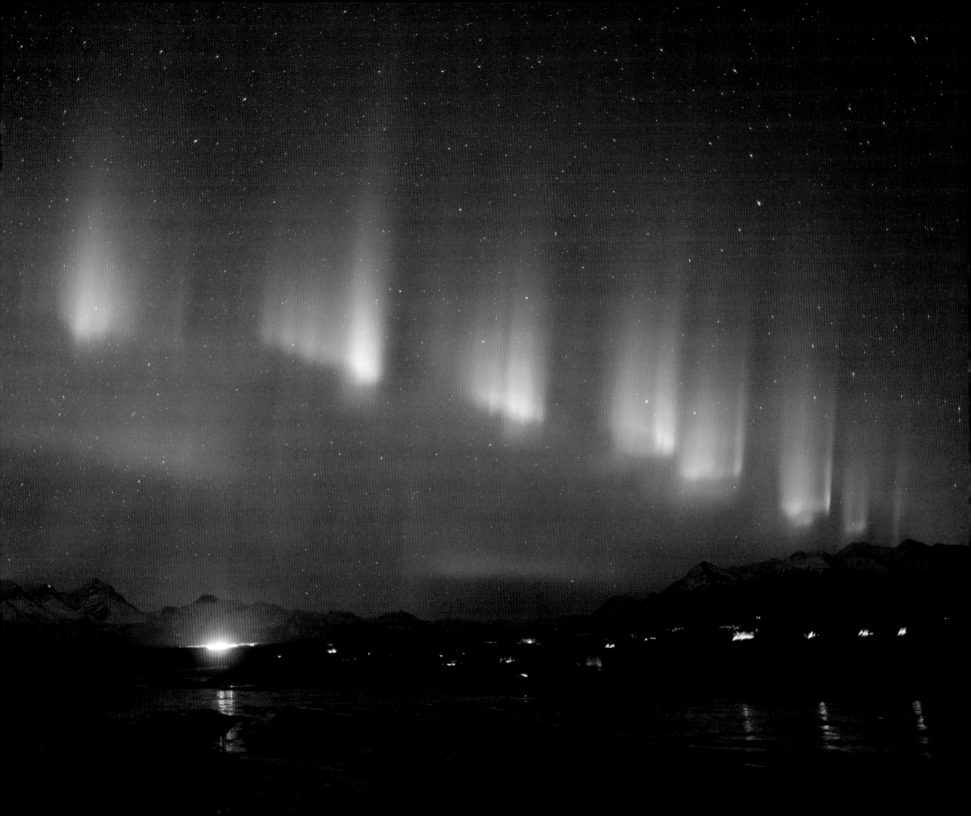

LEFT: A towering band of a colorful aurora over a braided Matanuska River on a clear March night.

RIGHT: A unique blue aurora over a mix of spruce and birch trees in the Knik River valley. The blue aurora is caused by sunlight hitting the top of the auroral curtain, so this only occurs near morning or evening twilight—in this instance, morning twilight, late April.

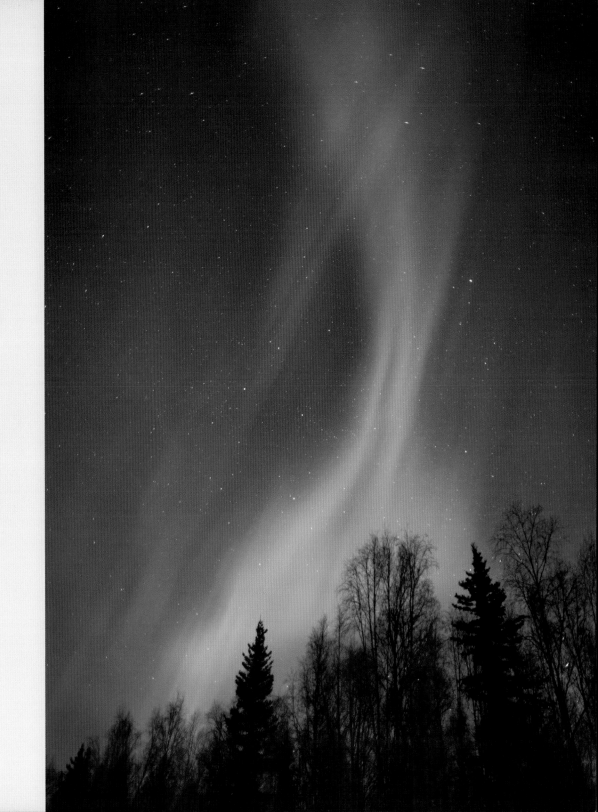

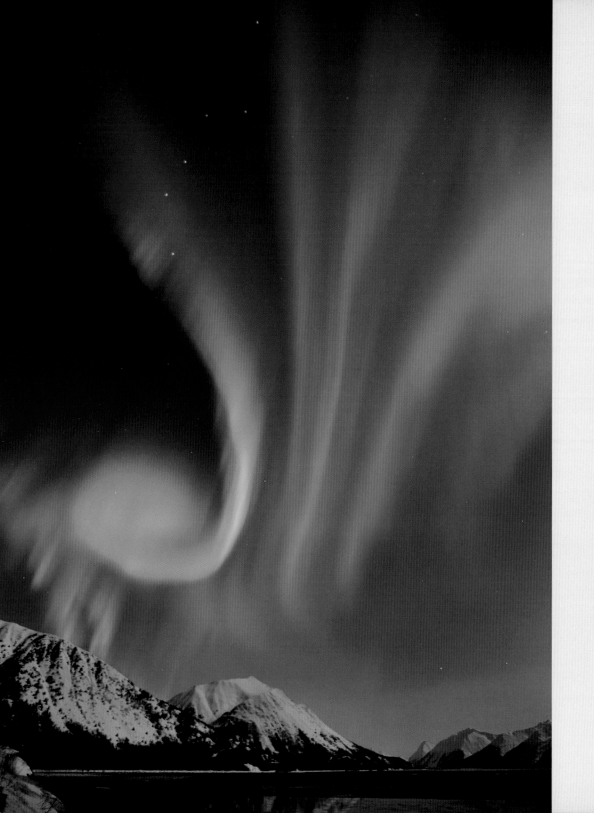

LEFT: A swirling fluorescent display of northern lights spins over Bird Ridge.

RIGHT: A moose grazes on willow sticks.

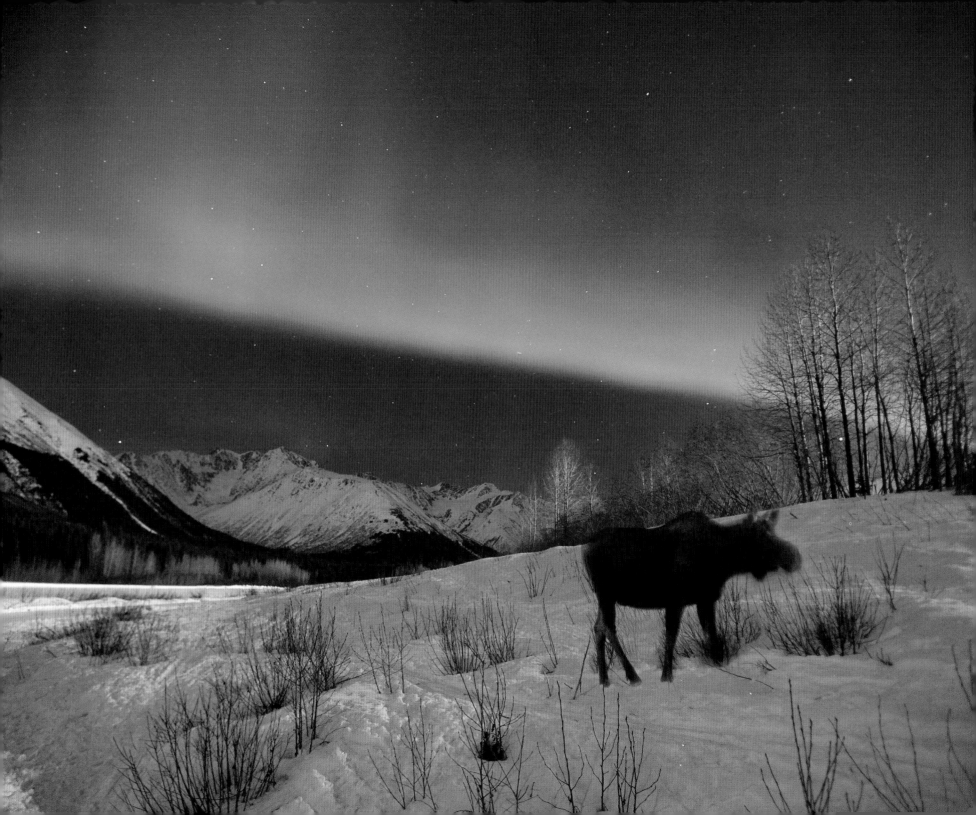

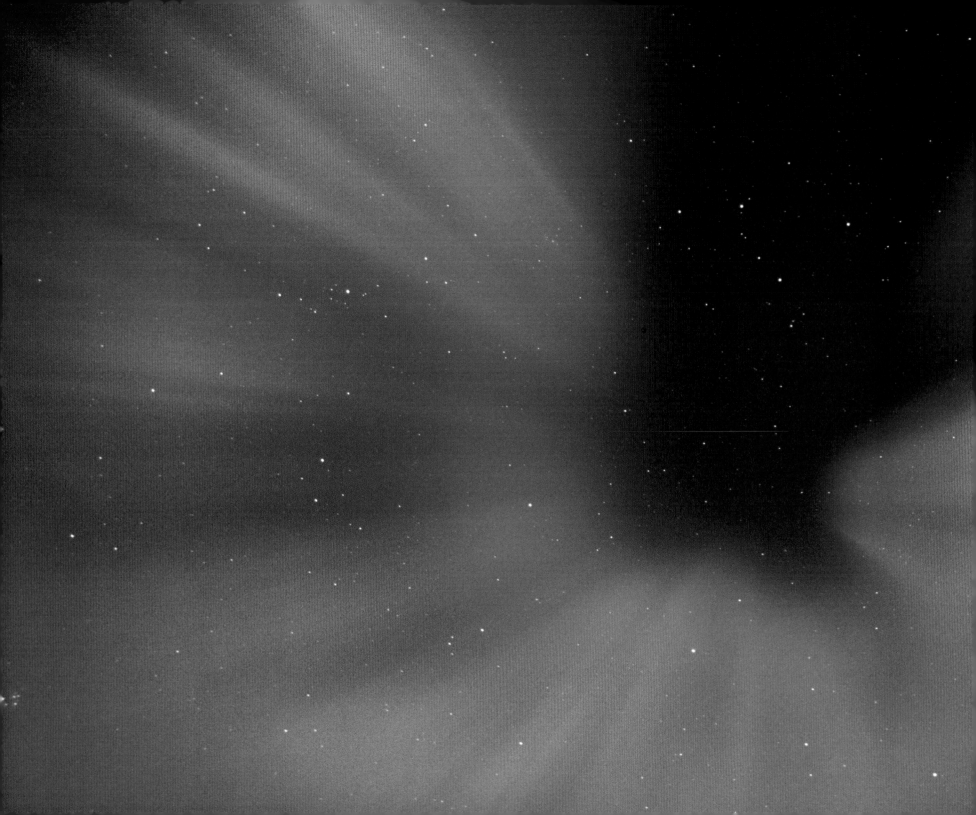

LEFT: A powerful corona aurora over the Glenn Highway, near Sheep Mountain Lodge. Traffic was minimal, so as Calvin Hall was driving and saw this begin, he jumped out of his truck and shot from the middle of the highway. This aurora maintained the central black area for a few minutes, which is pretty rare.

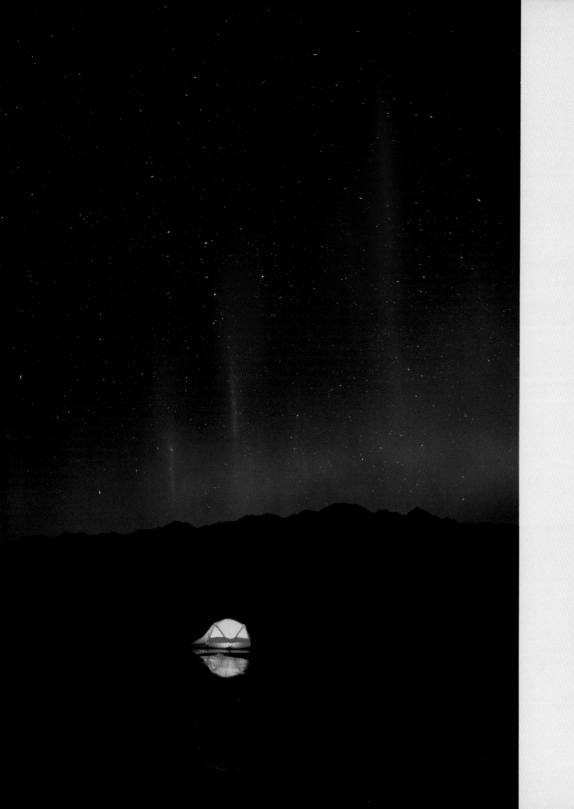

LEFT: After an unusual mid-winter thaw, open water in the Knik River valley reflects a tent and towering aurora.

RIGHT: With the coming daylight, a multicolor aurora rips through the southwestern sky above the Kenai Peninsula.

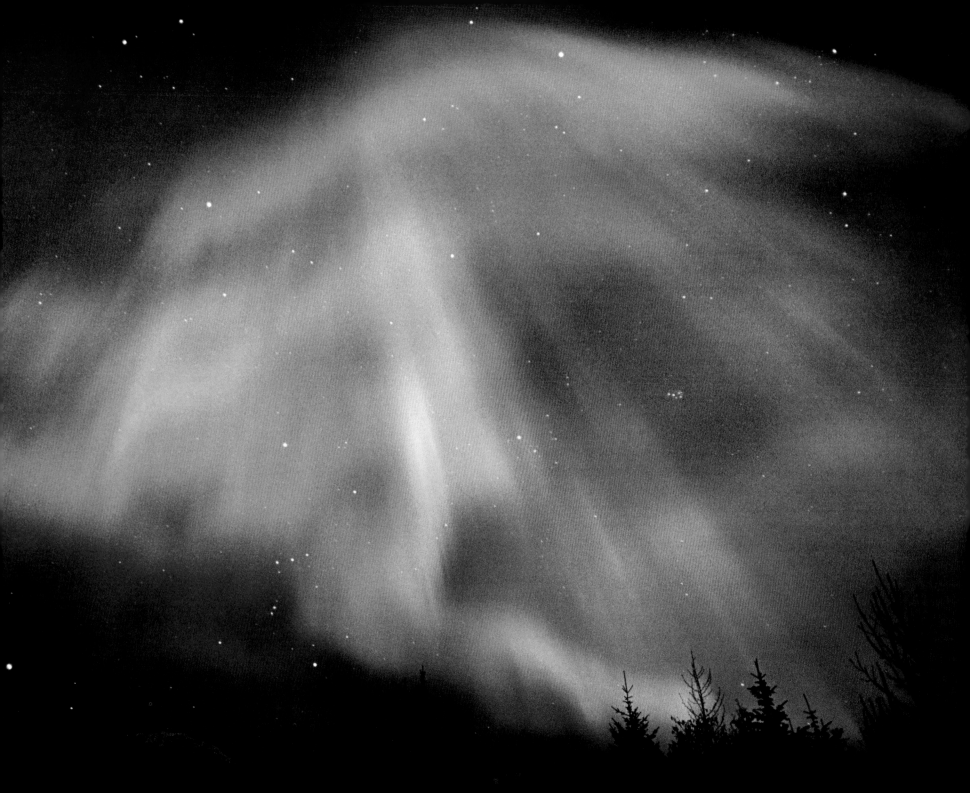

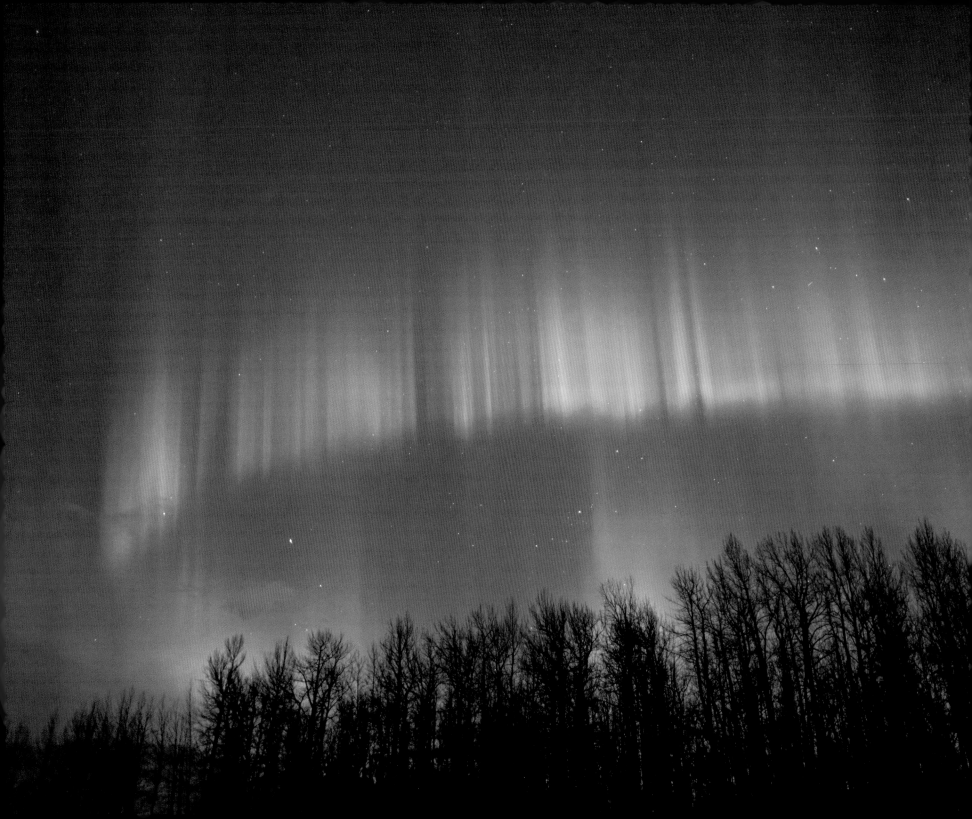

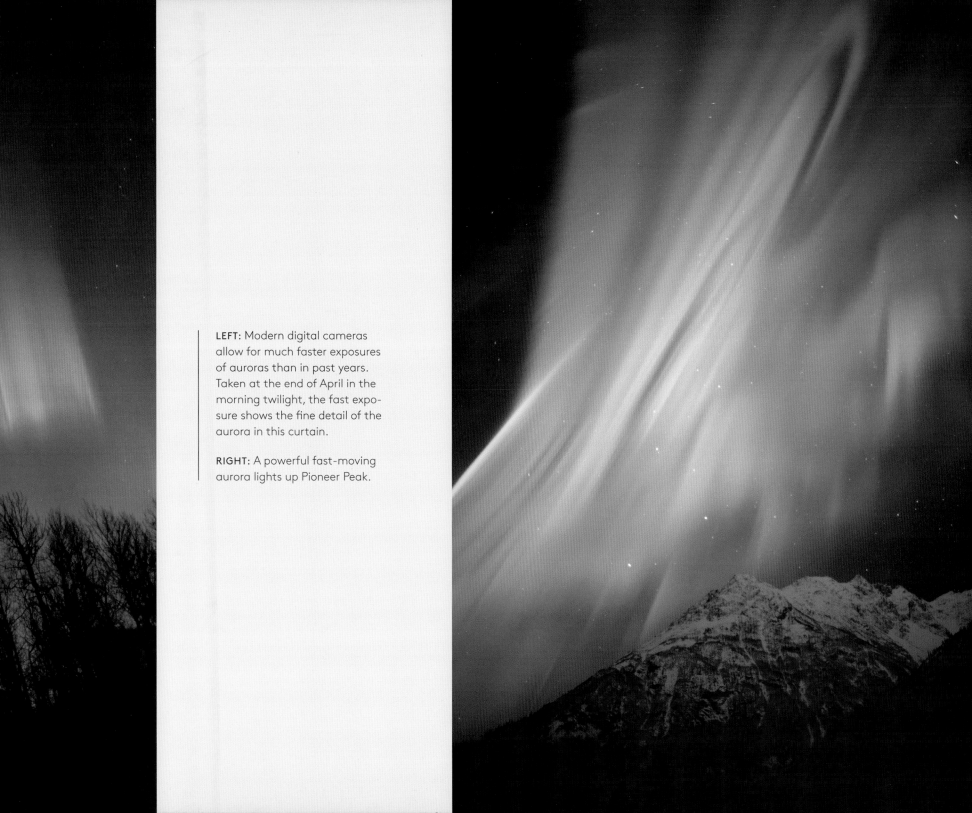

LEFT: Modern digital cameras allow for much faster exposures of auroras than in past years. Taken at the end of April in the morning twilight, the fast exposure shows the fine detail of the aurora in this curtain.

RIGHT: A powerful fast-moving aurora lights up Pioneer Peak.

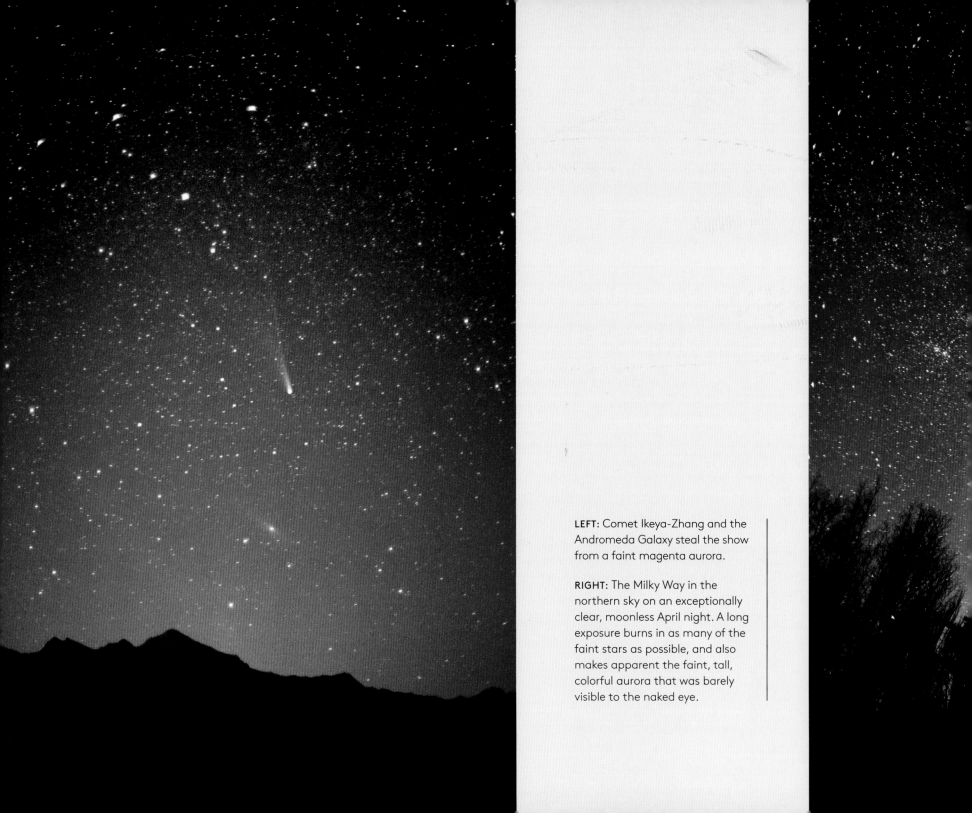

LEFT: Comet Ikeya-Zhang and the Andromeda Galaxy steal the show from a faint magenta aurora.

RIGHT: The Milky Way in the northern sky on an exceptionally clear, moonless April night. A long exposure burns in as many of the faint stars as possible, and also makes apparent the faint, tall, colorful aurora that was barely visible to the naked eye.

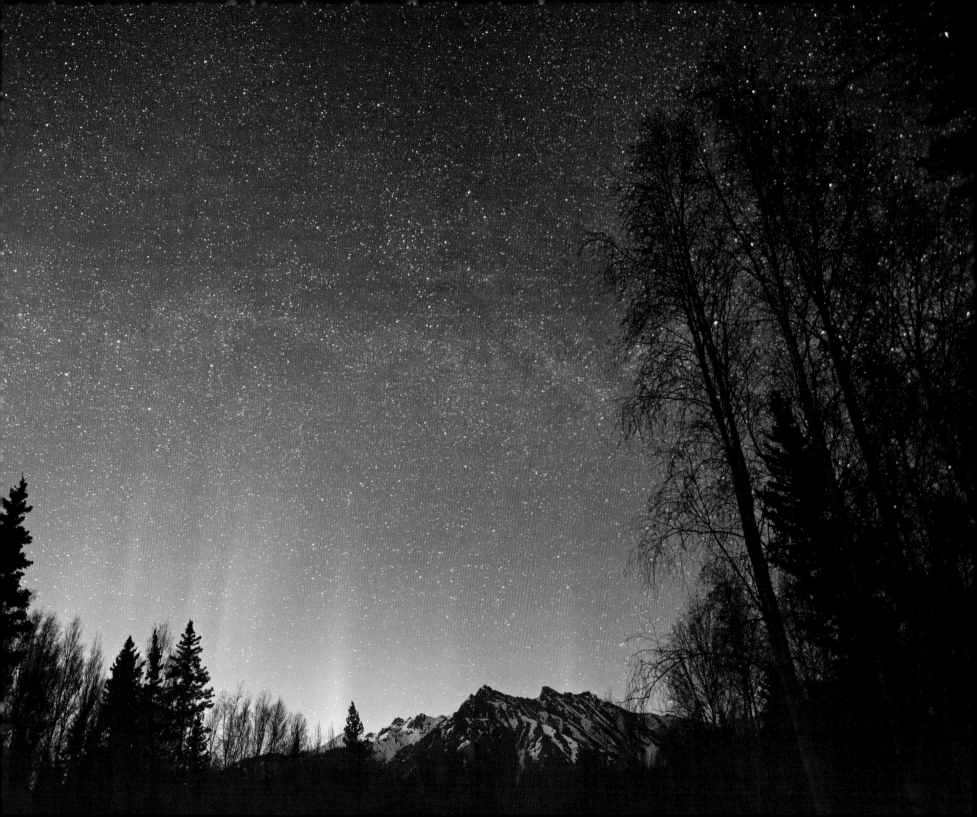

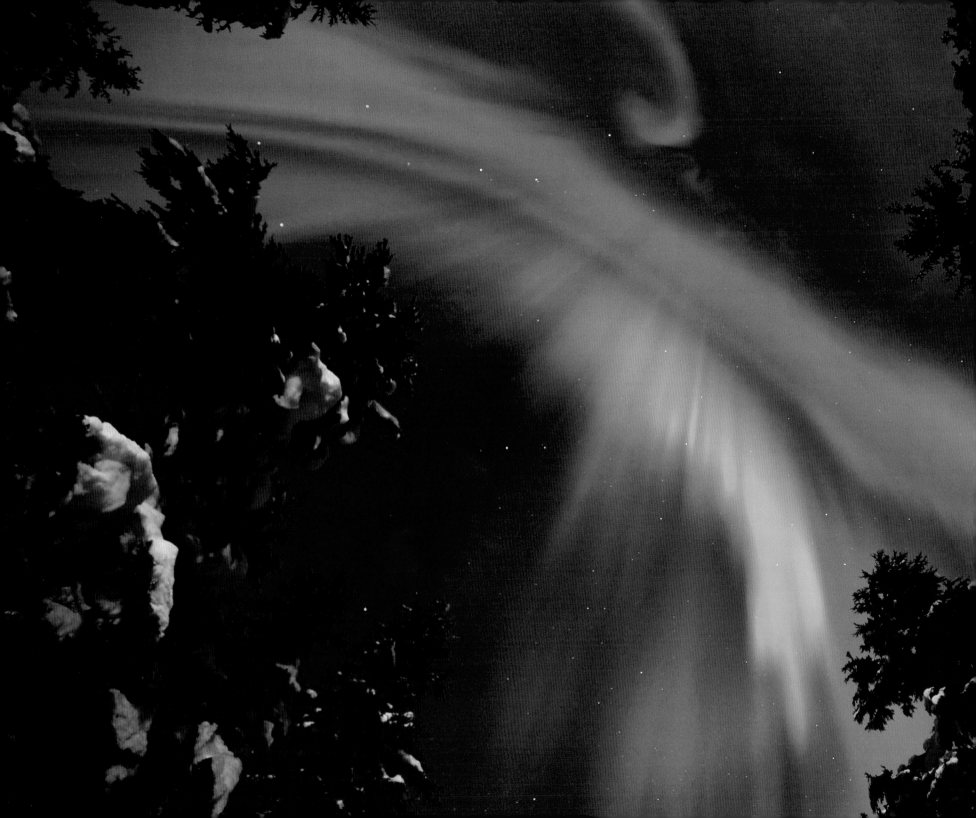

★

The northern cheek of the heavens,
By a sudden glory kissed,
Blushed to the tint of roses,
And hid in an amber mist,
And through the northern pathway,
Trailing her robe of flame,
The queenly Borealis
In her dazzling beauty came!

—MAY RILEY SMITH,
"Aurora Borealis"

RIGHT: Northern lights ripple atop the
trees lining the Iditarod Trail.

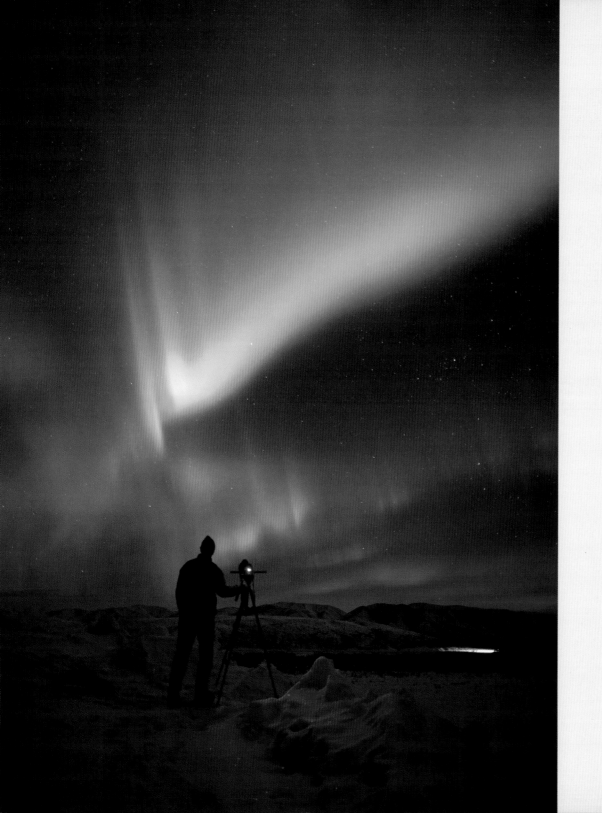

LEFT: Photographer Calvin Hall takes a self-portrait while photographing an aurora near Eureka, Alaska. Lights from cars on the Glenn Highway shine in the distance.

RIGHT: A beautiful corona aurora captured near the Parks Highway, south of the Alaska Range.

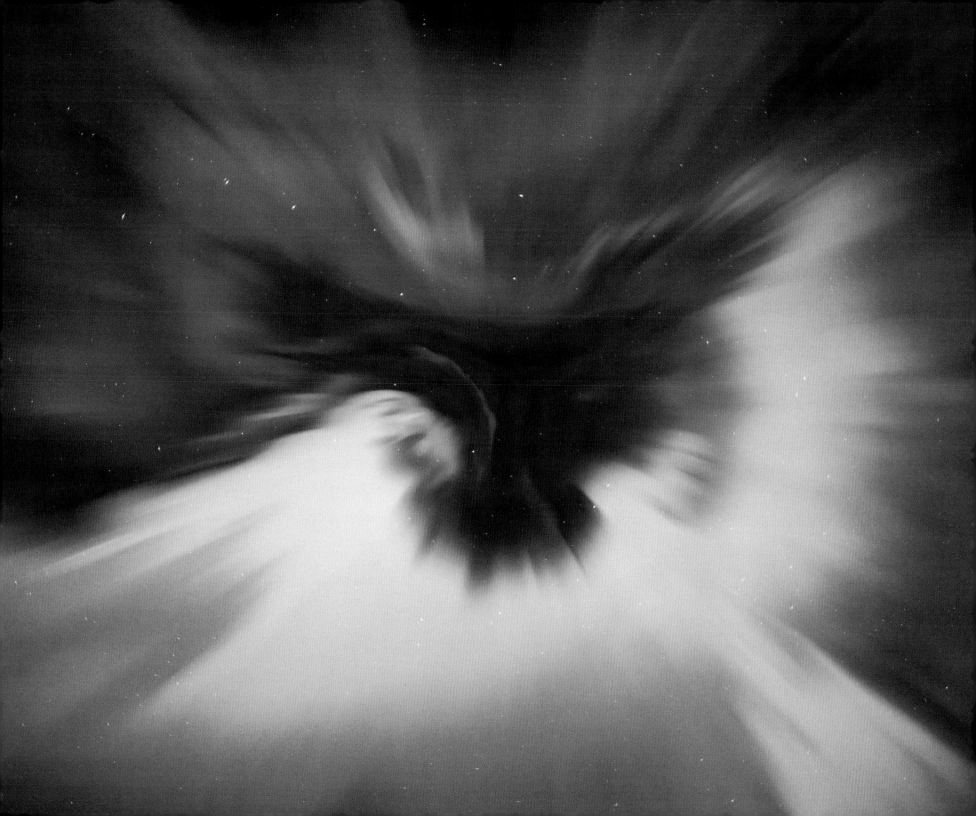

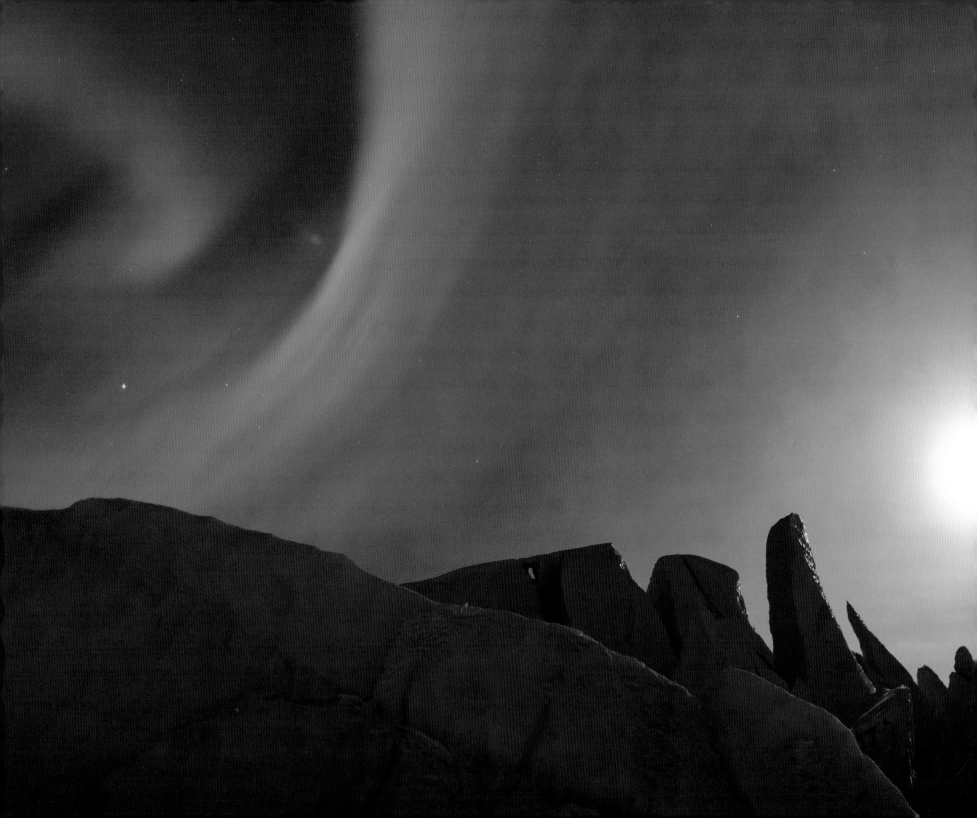

LEFT: An aurora dances over the spires of the Matanuska Glacier in early April. A partial moon shining through the thin clouds brightens the scene.

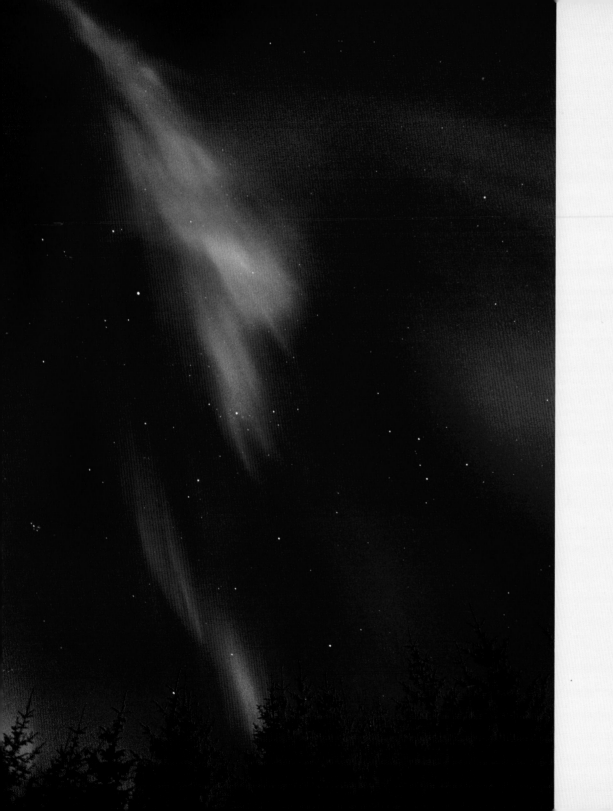

★

The north! the north! from out the north
What founts of light are breaking forth,
And streaming up these evening skies,
A glorious wonder to our eyes!

—HANNAH FLAGG GOULD,
"The Aurora Borealis"

LEFT: An unusual midnight blue aurora twists through the northern skies.

RIGHT: An aurora over a camp set up on an iceberg and the Knik Glacier.

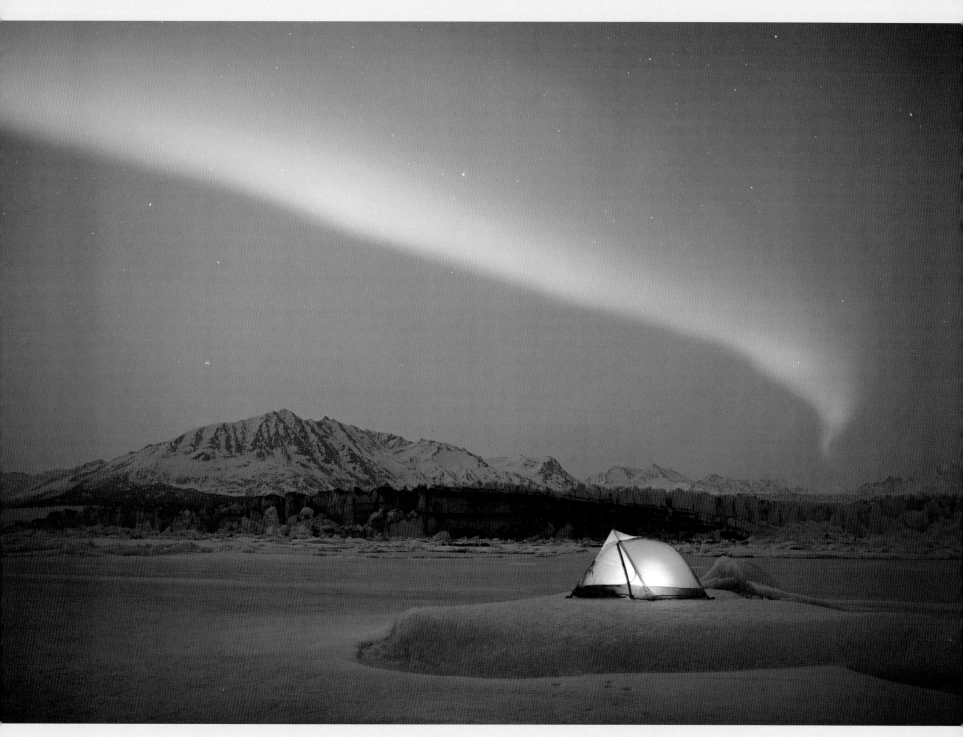

RIGHT: An aurora over Denali from milepost 134 of the Parks Highway area. The Big Dipper is low and right-side up in the fall in Alaska, and adds a nice accent to the night sky.

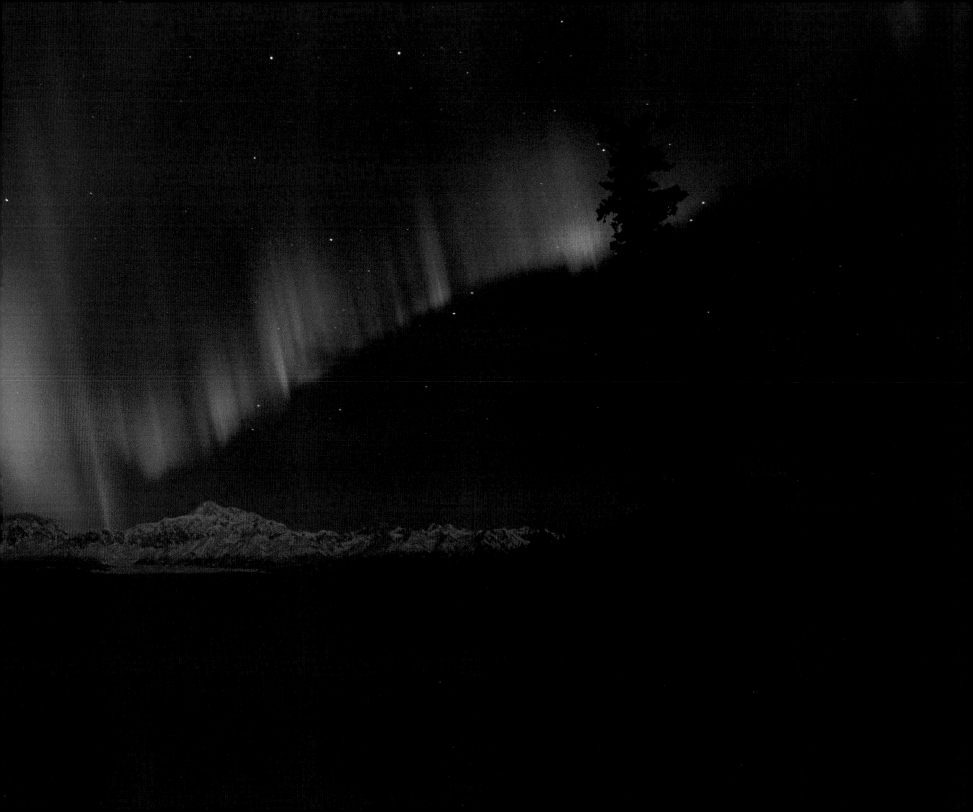

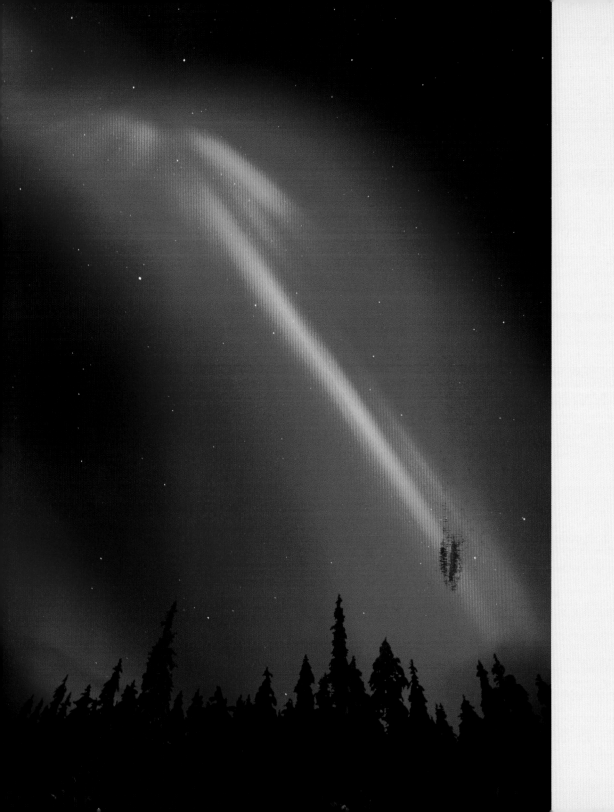

LEFT: Turnagain Pass glows bright red in this extraordinary early November display that began as the sun was setting.

RIGHT: An all-sky 8mm image of a colorful aurora in the Knik River valley, with the Chugach Mountains on the horizon.

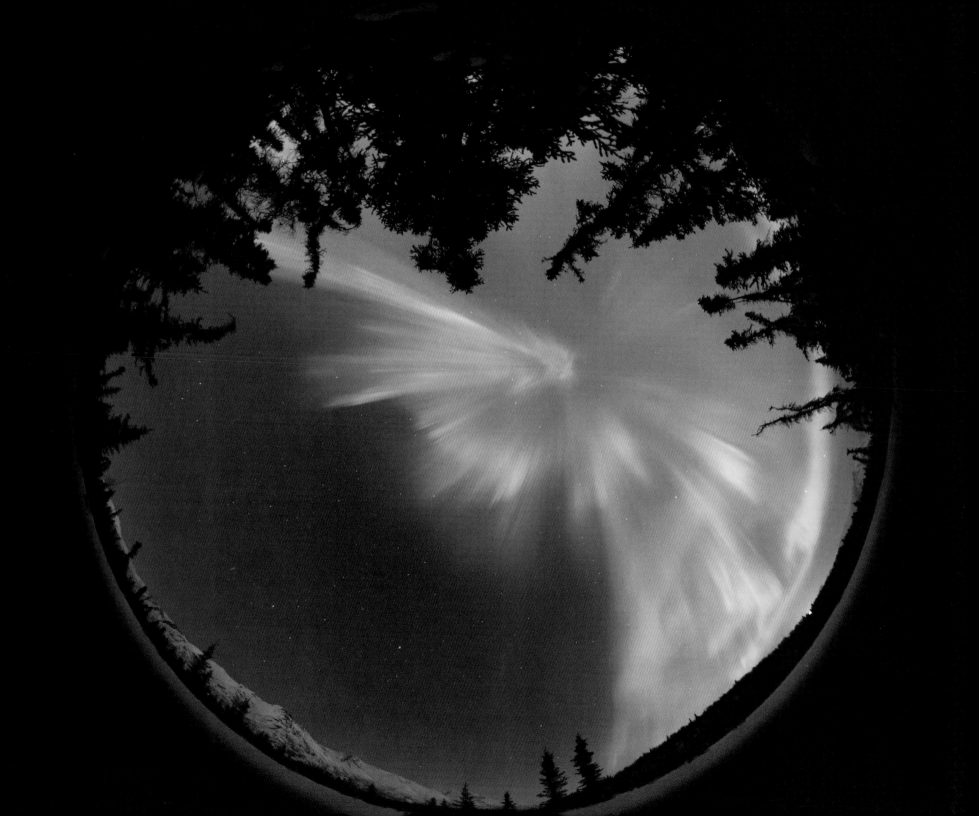

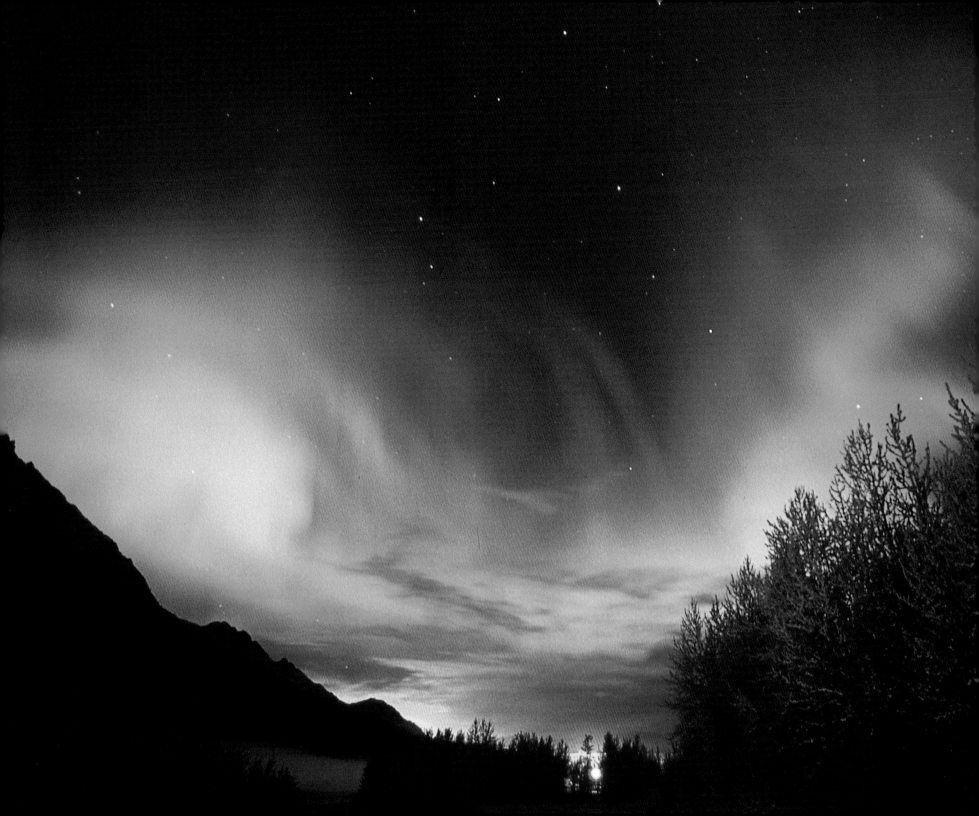

LEFT: As the moon sets in the western sky, an aurora flares up over the frosty Knik River.

RIGHT: A glowing, pulsing, colorful aurora over a radio and cell tower near Eureka.

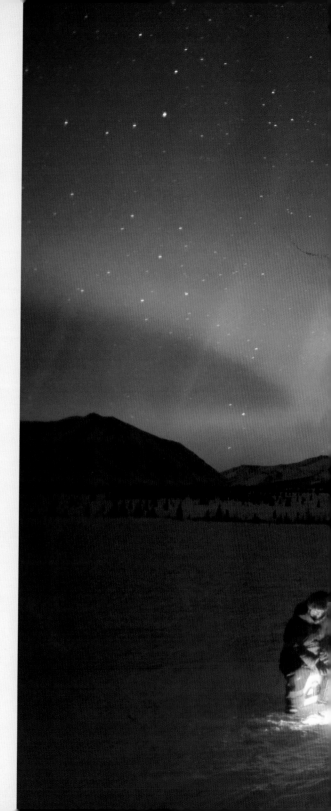

RIGHT: Above a winter camp at Broad Pass, a rare stationary purple arc that can be seen for hundreds of miles.

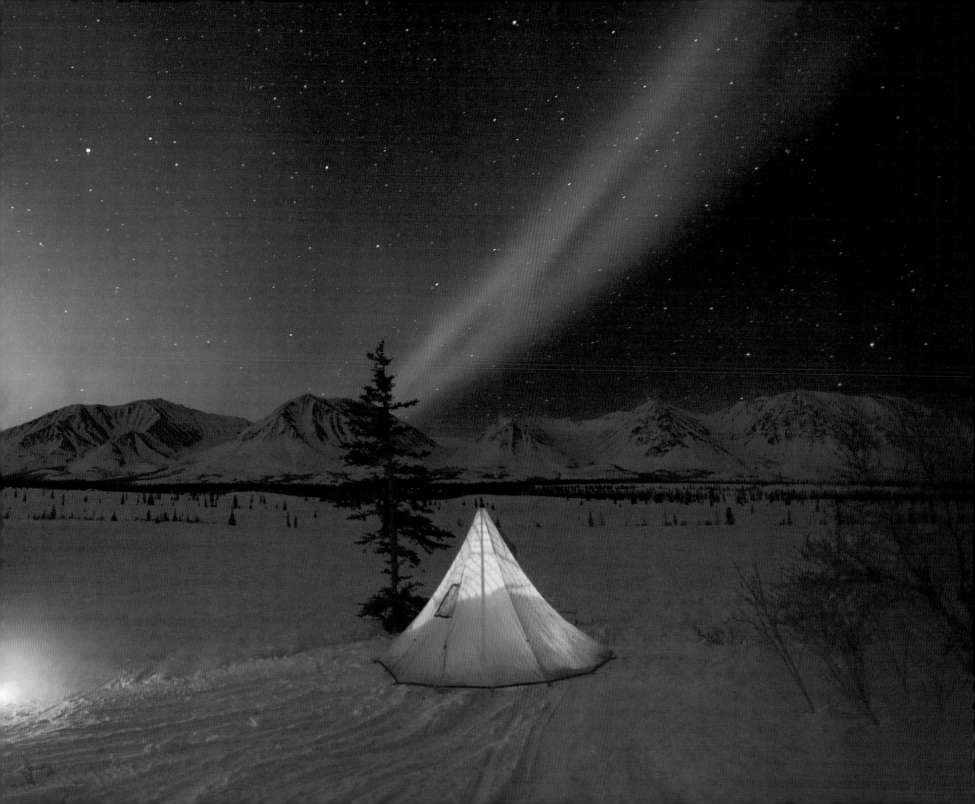

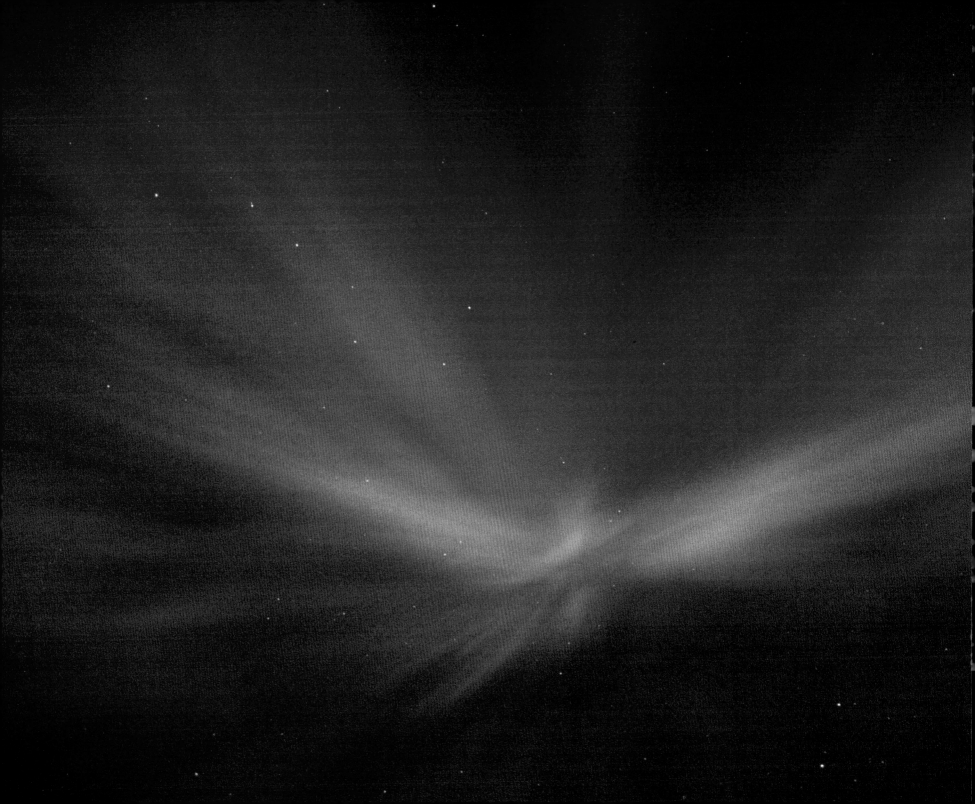

LEFT: If you have used a computer lately, this might look familiar.

RIGHT: A cabin at Sheep Mountain Lodge on the Glenn Highway.

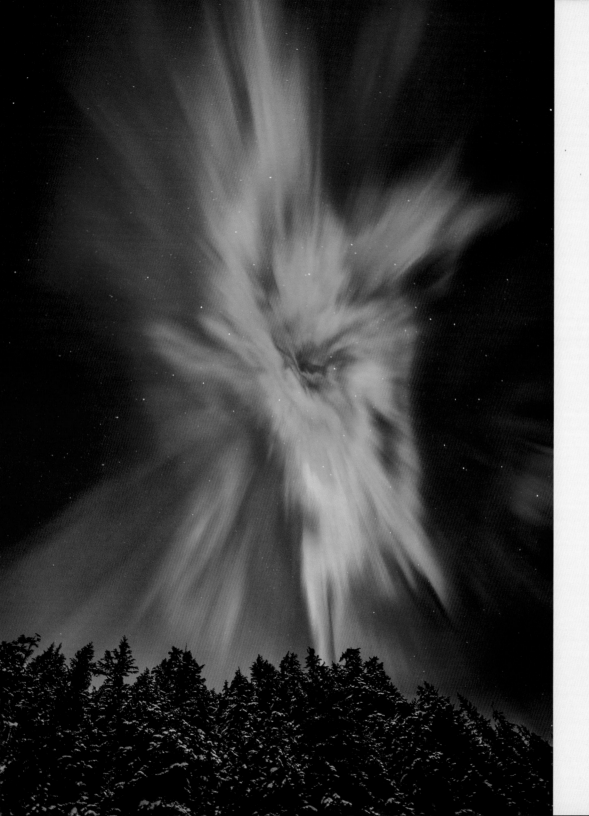

LEFT: A corona aurora explodes above the Chugach Mountains.

RIGHT: The Swanberg Dredge, a 1940s mining relic and now historical landmark, sits on the edge of the gold rush town of Nome, Alaska, on a brutally cold and windy night.

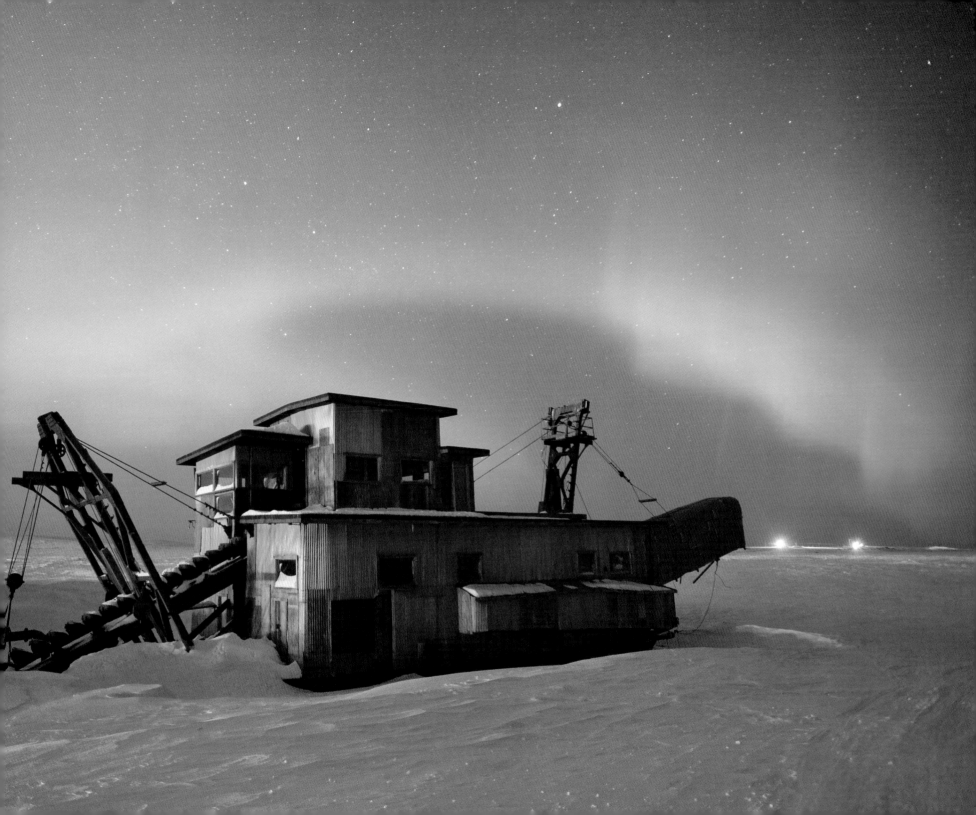

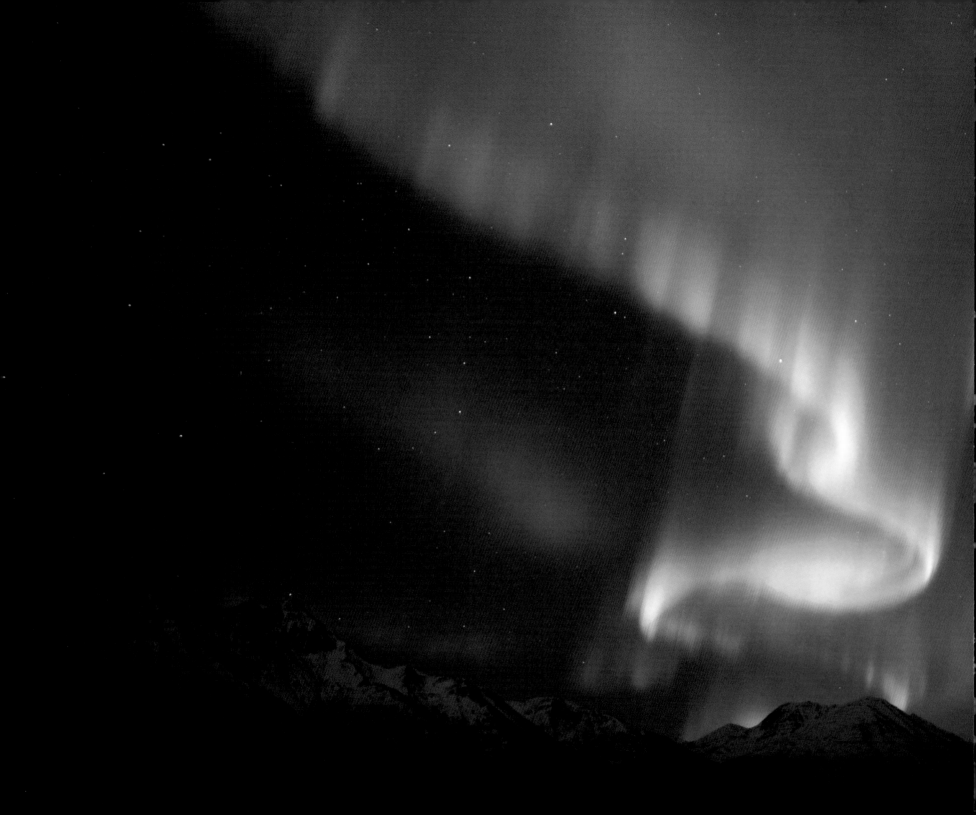

LEFT: This aurora moved over the Chugach Mountains like a whip, a coiled and then straight ripple of light extending over the mountain ridgeline on a peaceful March night.

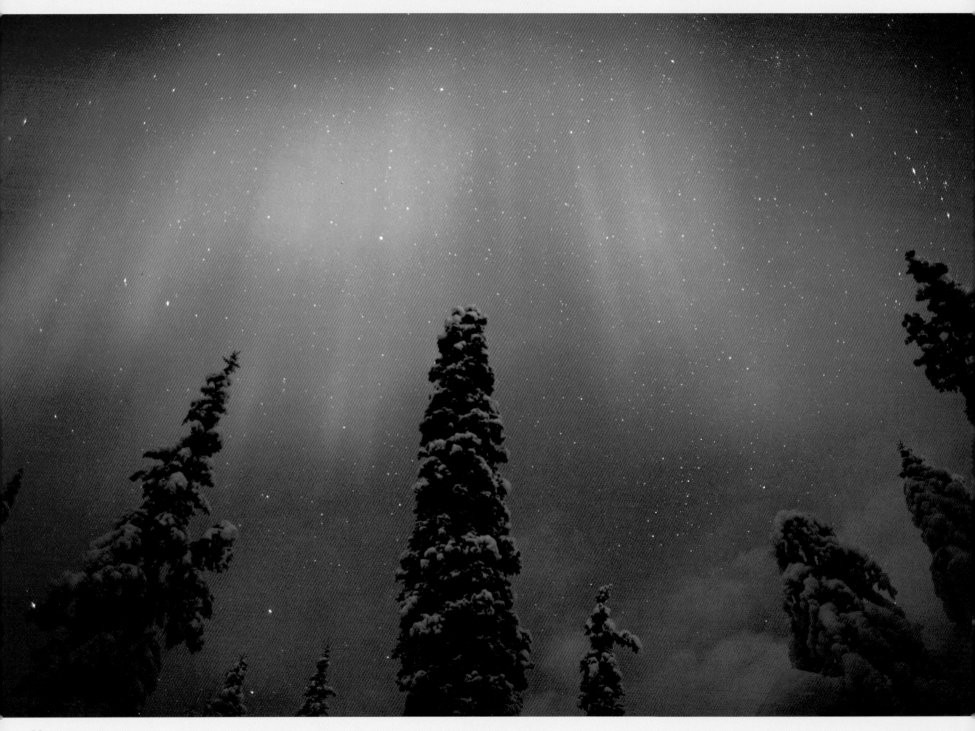

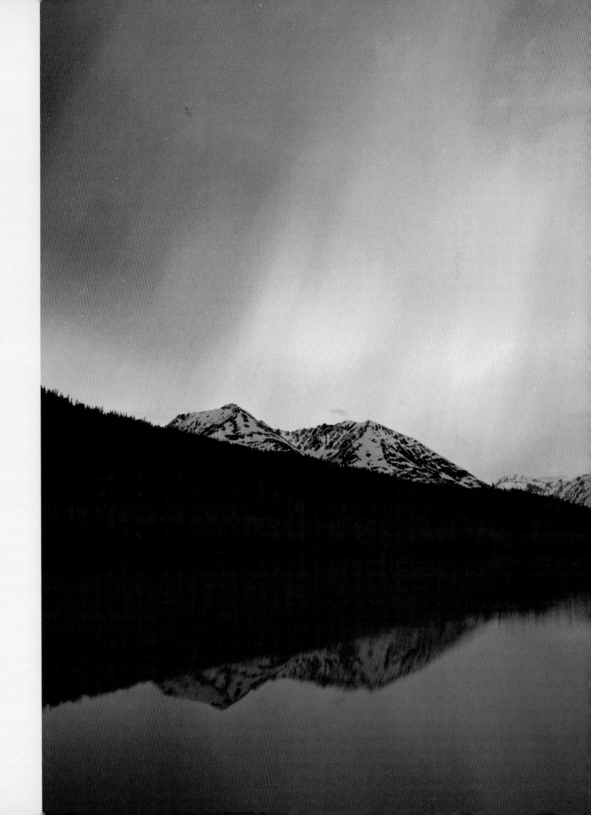

LEFT: An opening in the clouds allows a brief view of the results of a solar storm.

RIGHT: A solar storm in the southern sky near Seward, Alaska.

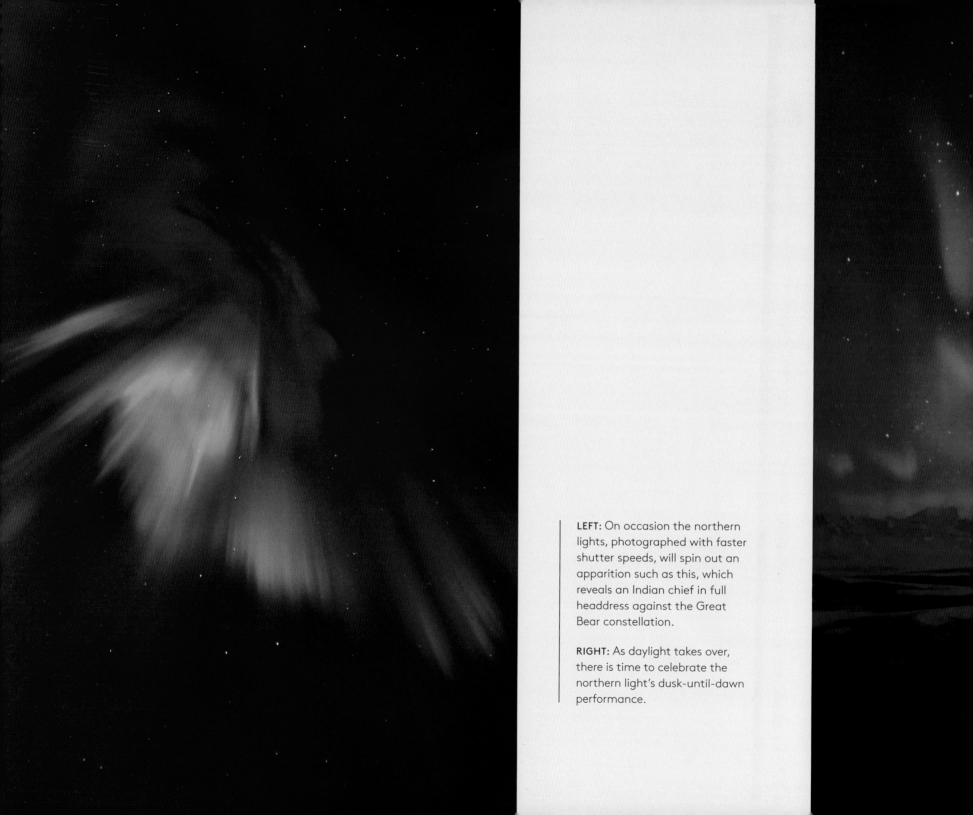

LEFT: On occasion the northern lights, photographed with faster shutter speeds, will spin out an apparition such as this, which reveals an Indian chief in full headdress against the Great Bear constellation.

RIGHT: As daylight takes over, there is time to celebrate the northern light's dusk-until-dawn performance.

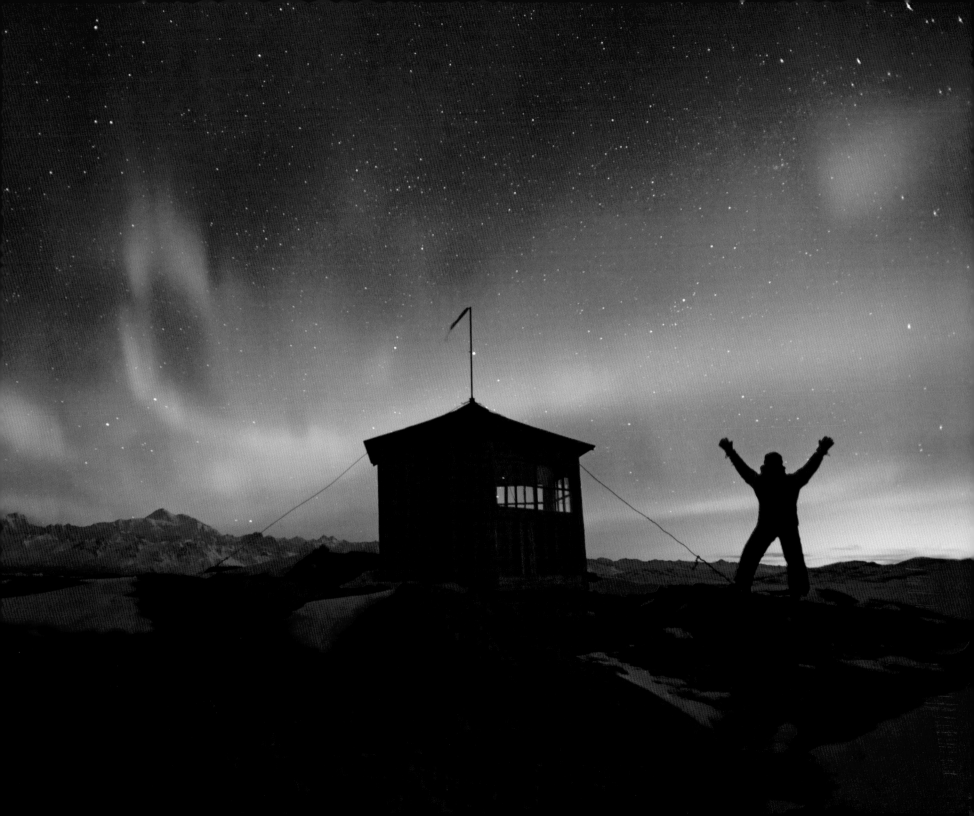

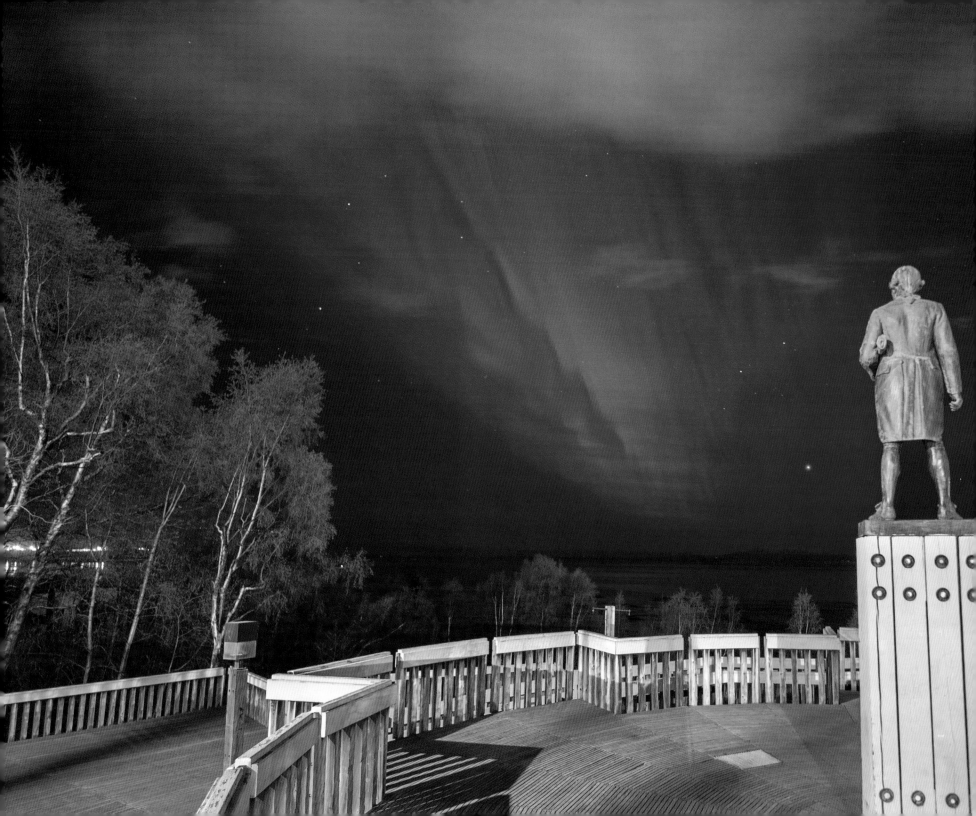

LEFT: The Captain Cook statue, located on the observation deck in downtown Anchorage, faces the northern lights that stream through the western skies above the Cook Inlet.

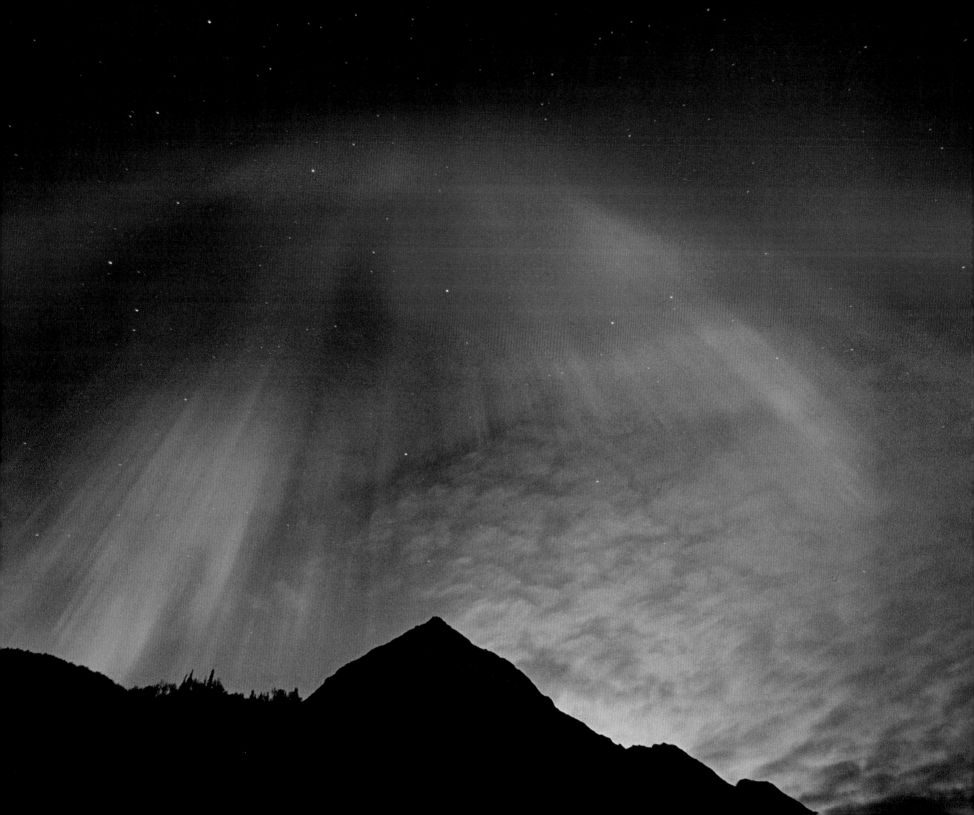

LEFT: Pioneer Peak from the edge of the Knik River, and taken toward the southwest.

RIGHT: Shot on slide film with a slower shutter speed, this image of a corona aurora exploding in the southwestern sky features a soft blend of multicolor light.

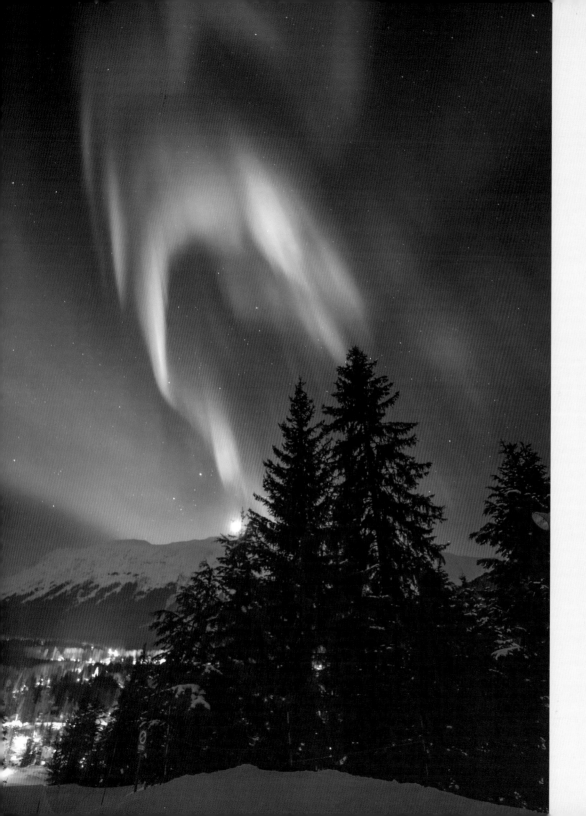

LEFT: As the moon sets atop Penguin Ridge, the aurora illuminates the mountainside during this energetic display.

RIGHT: Corona auroras can form a focused center point very quickly and then suddenly disappear.

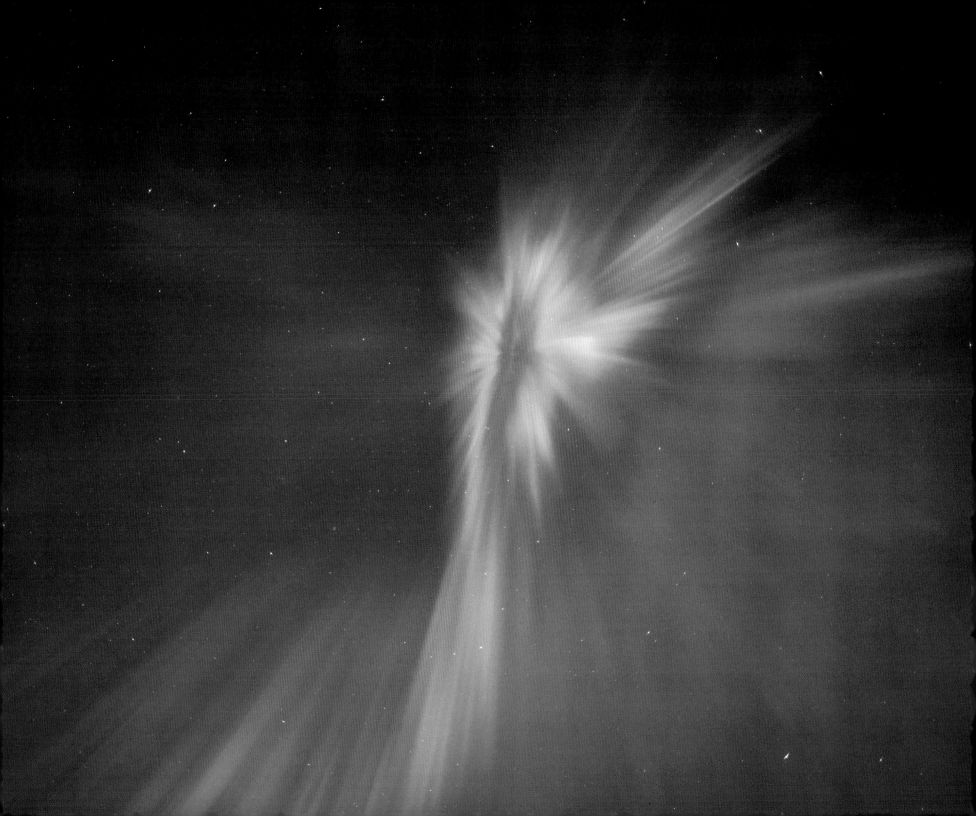

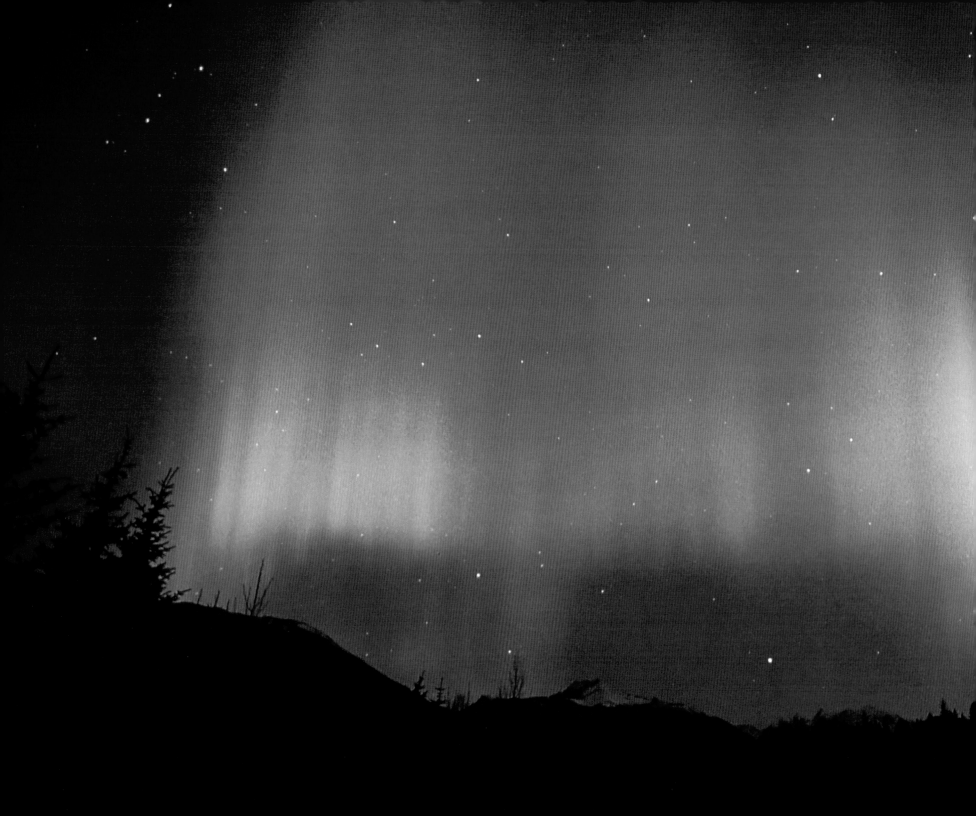

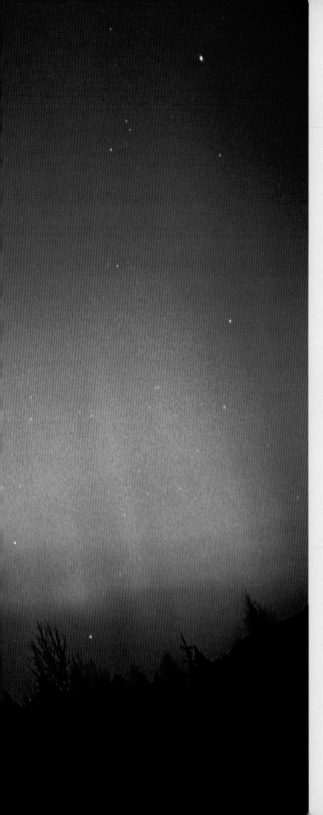

★

Aurora had but newly chased the night,
And purpled o'er the sky with blushing light.

—**JOHN DRYDEN**,
Palamon and Arcite

LEFT: Magenta curtains ripple above
the ski resort community of Girdwood.

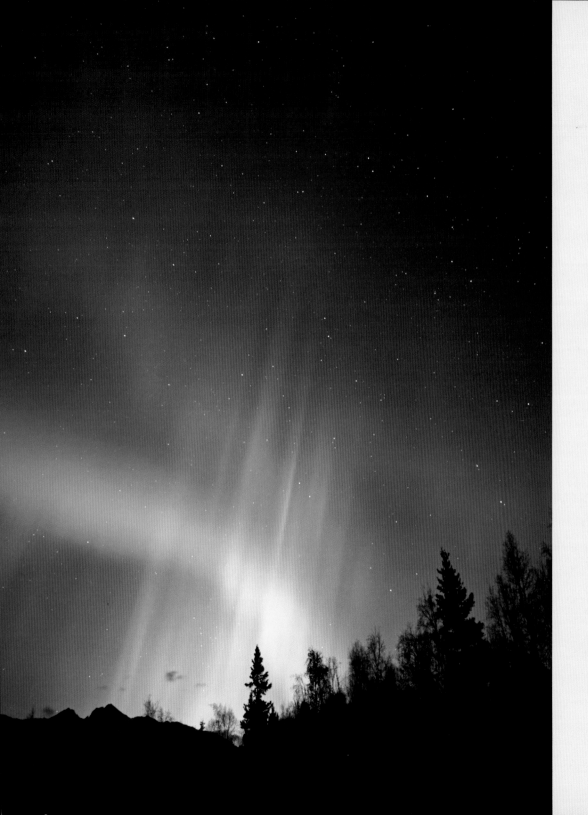

LEFT: A unique blue aurora over the Chugach Mountains in the Knik River valley. The blue is caused by sunlight hitting the top of the aurora near sunrise or sunset.

RIGHT: The northern lights dance in the moonlit sky above Fish Lake off the Talkeetna Spur Road on a beautiful and frigid (about negative thirty degrees Fahrenheit) February night.

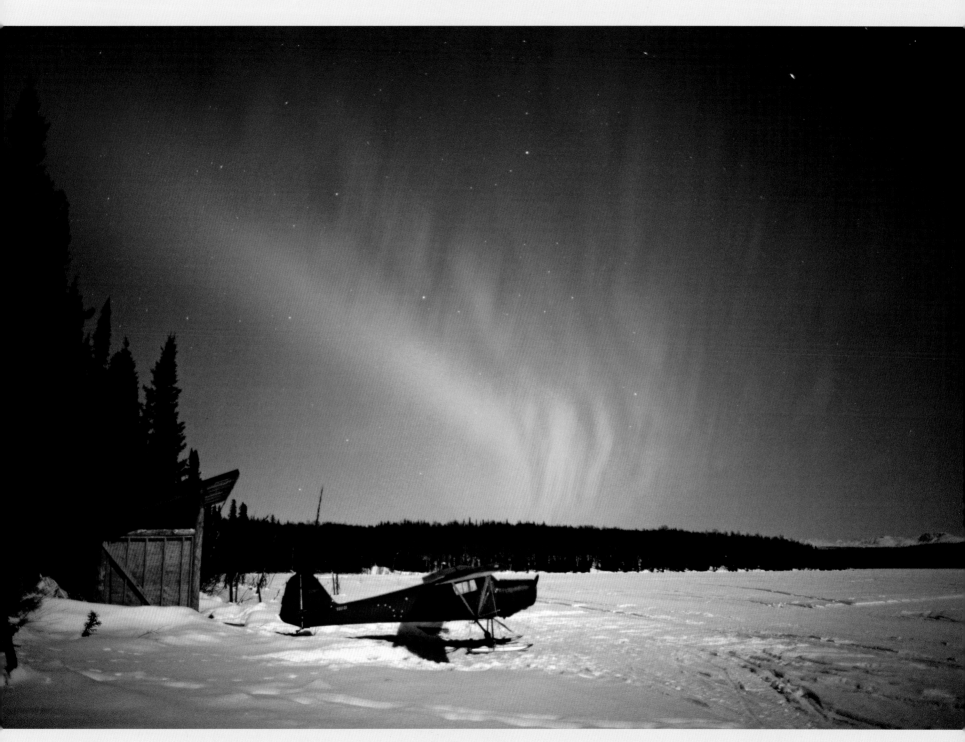

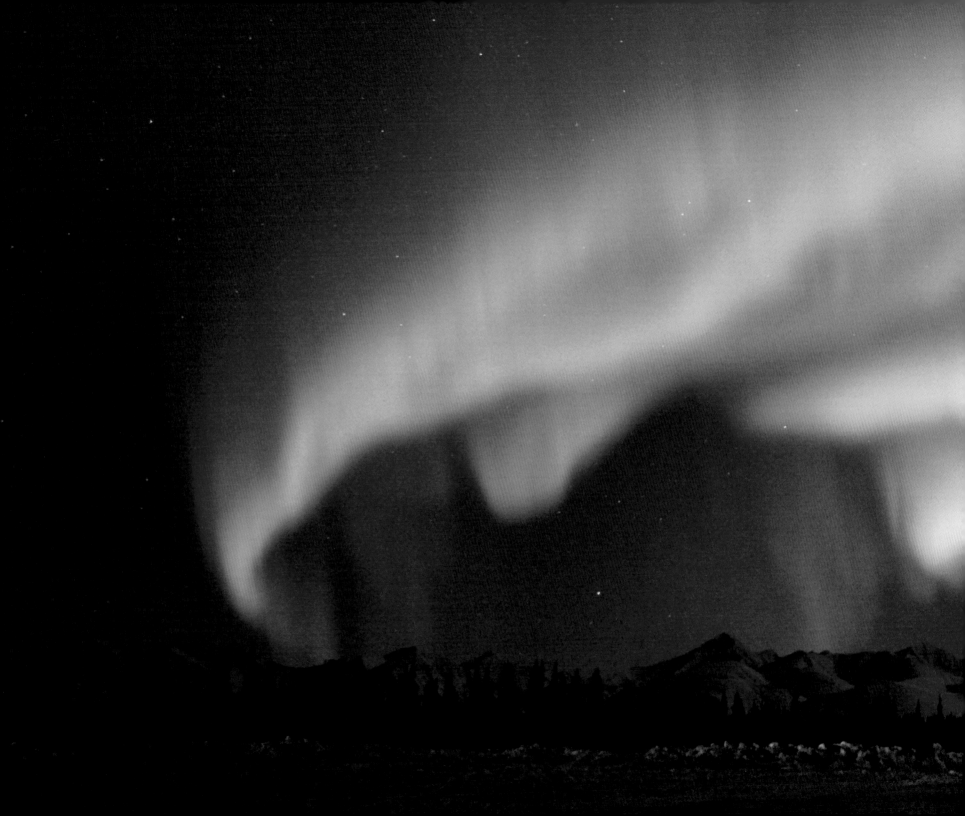

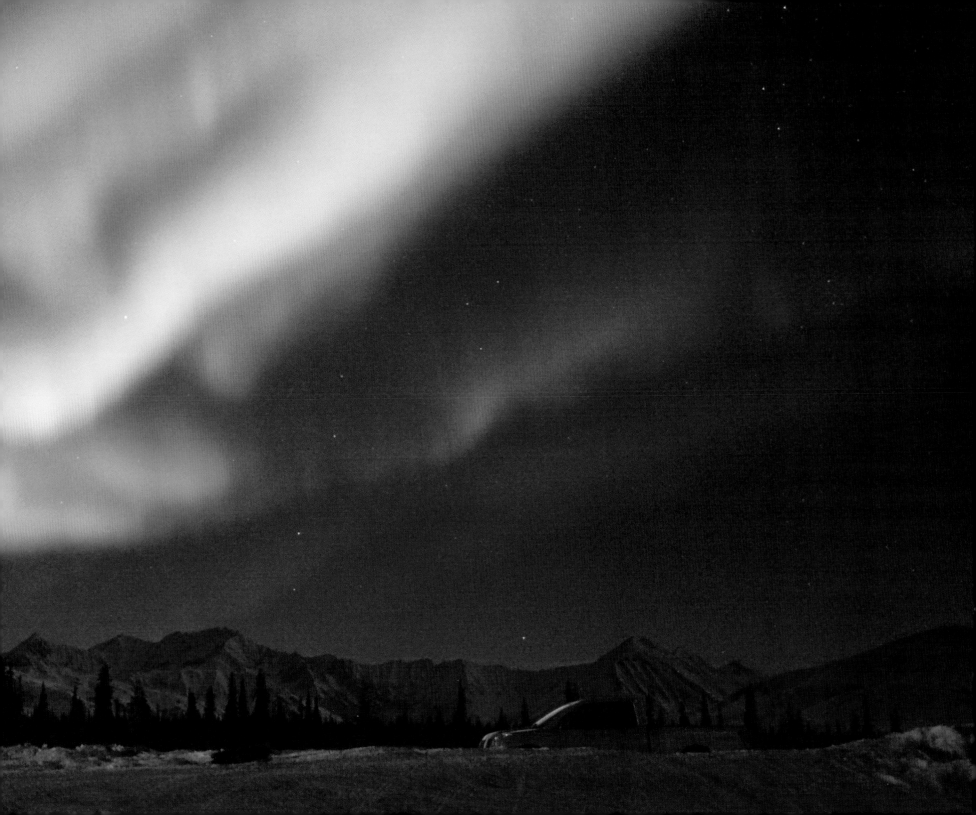

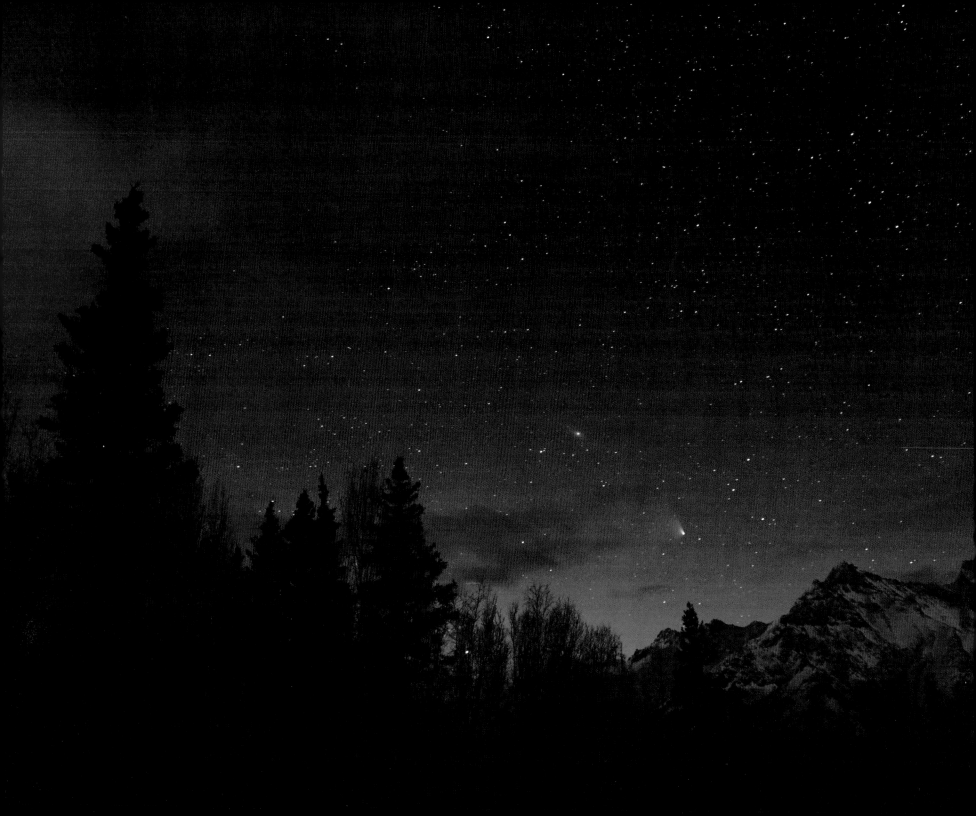

PREVIOUS PAGE: The light show comes on strong over Broad Pass during the March equinox.

LEFT: A faint aurora with the Andromeda Galaxy and comet 2011 L4 (PANSTARRS) over the Chugach Mountains.

RIGHT: A long exposure star trail picture turned into an aurora photo as the northern lights flared up during the shot, taken over the Glenn Highway near Gunsight Mountain.

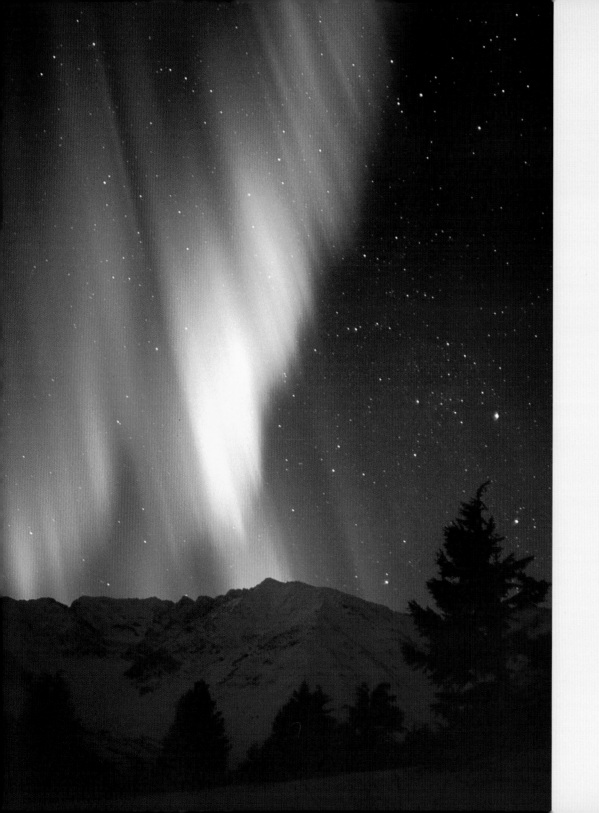

LEFT: High above the Chugach Mountains from the Crow Pass trailhead.

RIGHT: Saint Patrick's Day lights up south-central Alaska.

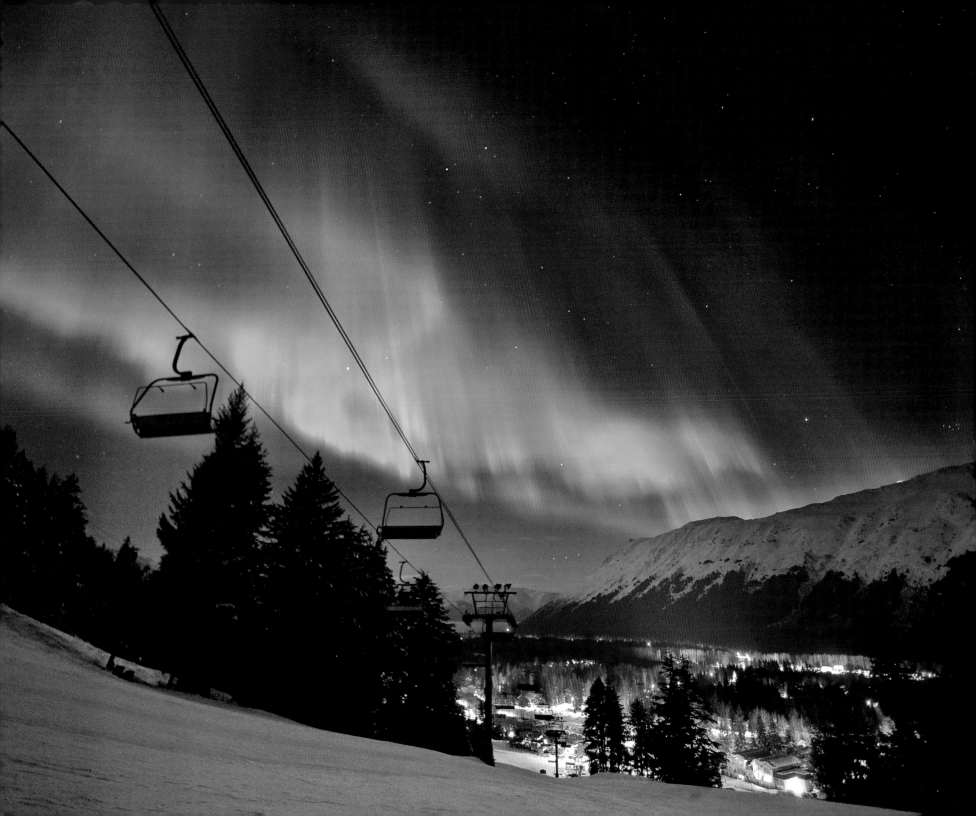

RIGHT: In the Knik River valley during spring, the open water and aurora aligned beautifully for this shot.

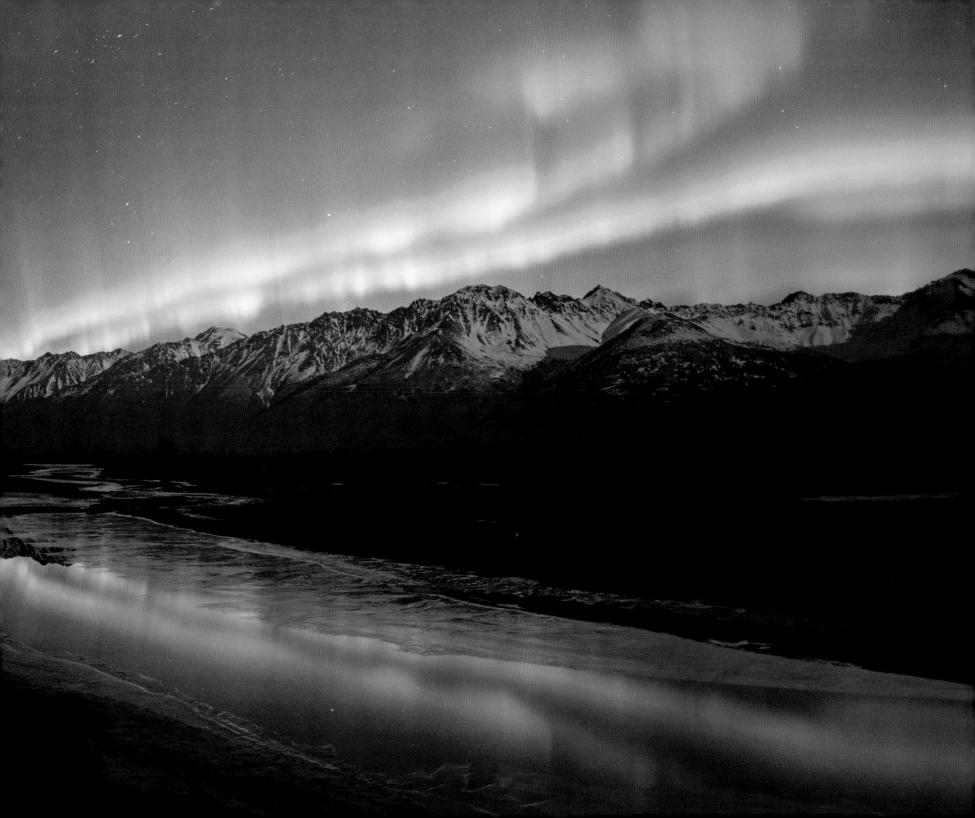

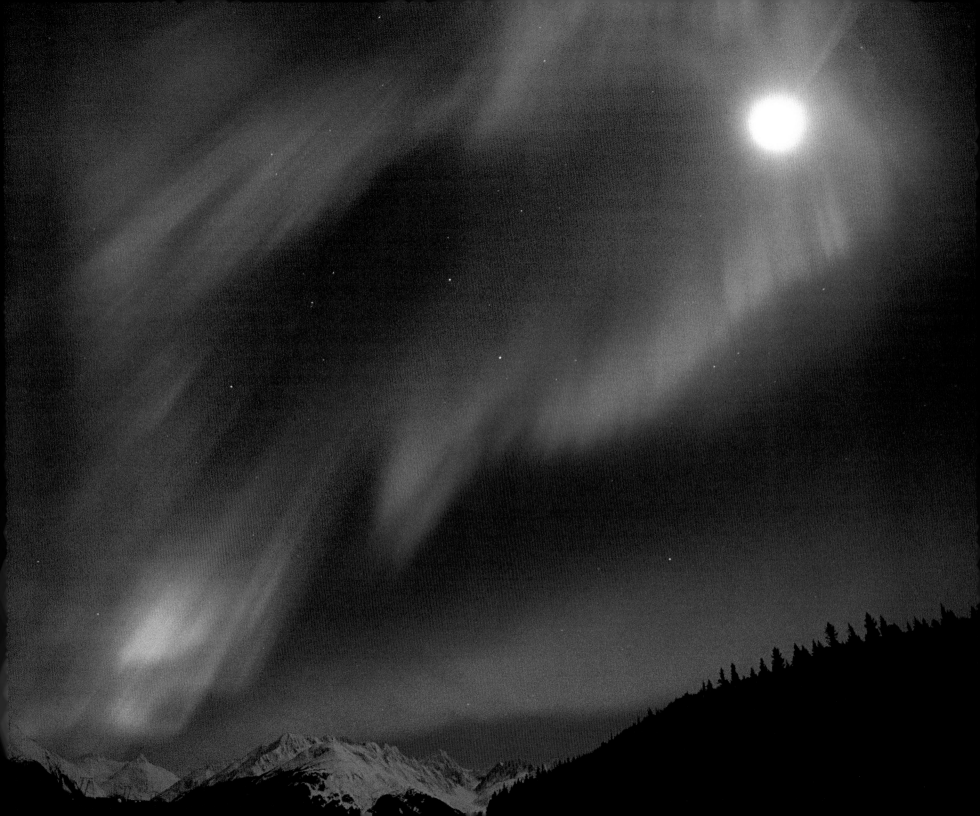

LEFT: Carpathian Peak is featured below the celestial light surrounding the moon above Placer River valley in south-central Alaska.

RIGHT: A rare December event, an ice-free Portage Lake with cloudless calm weather and bright moonlight.

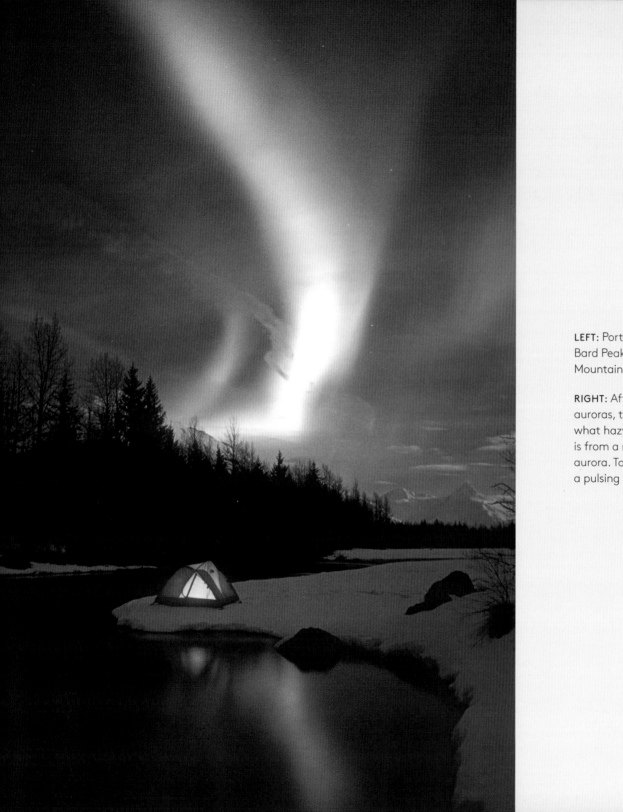

LEFT: Portage Creek with Bard Peak and the Chugach Mountains in the background.

RIGHT: After a night of strong auroras, the clear sky looks somewhat hazy, but that diffused look is from a remnant, disorganized aurora. To the eye this aurora has a pulsing rhythm to it.

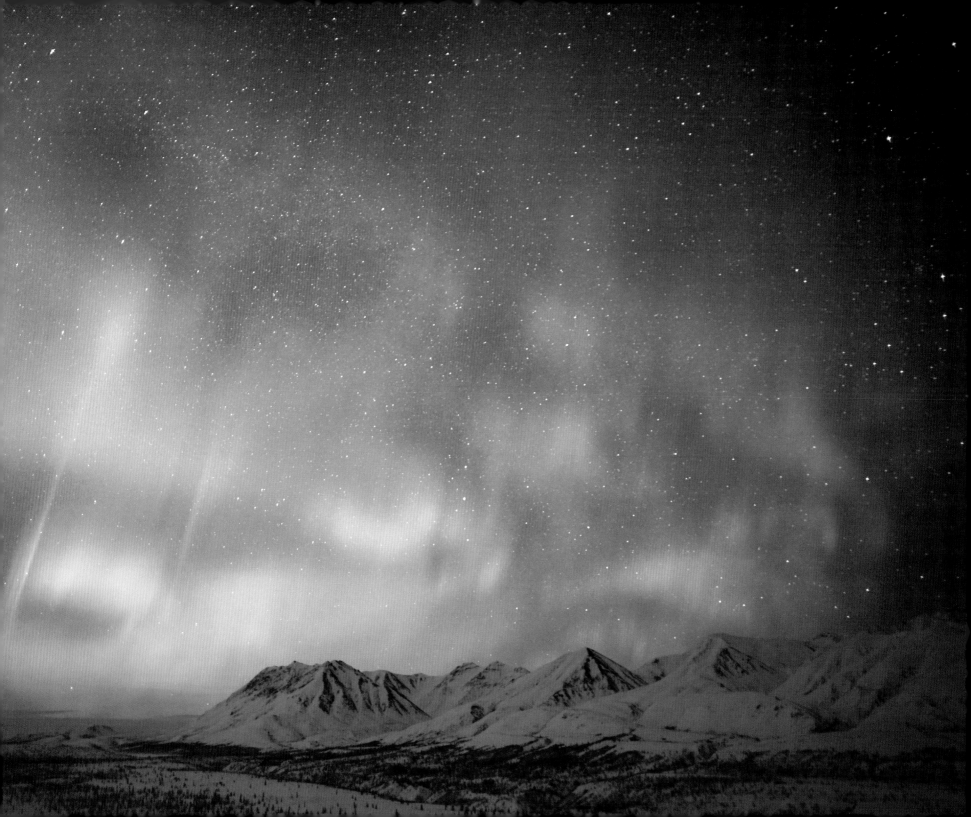

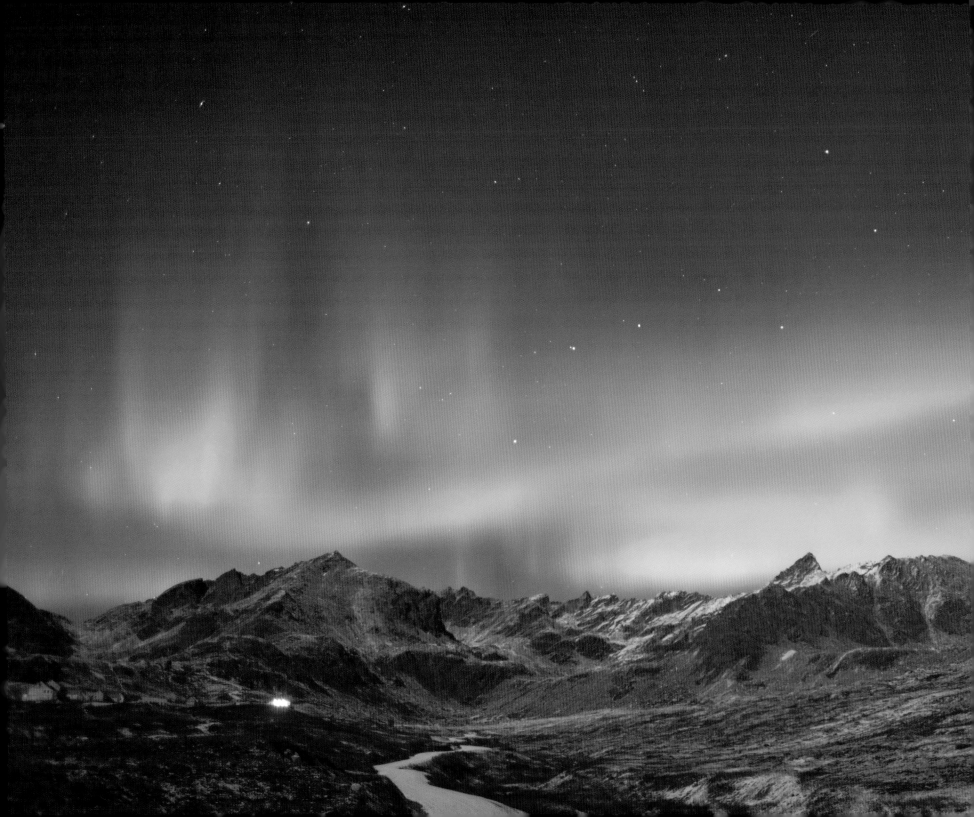

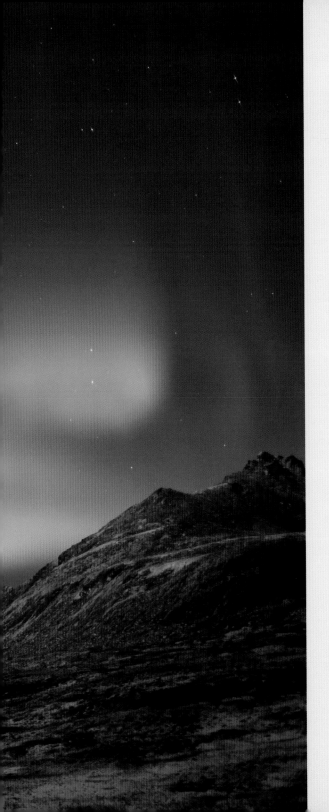

LEFT: The Big Dipper and a beautiful flowing aurora over Independence Mine in Hatcher Pass, taken on October 30 by moonlight, with uncharacteristically little snow cover.

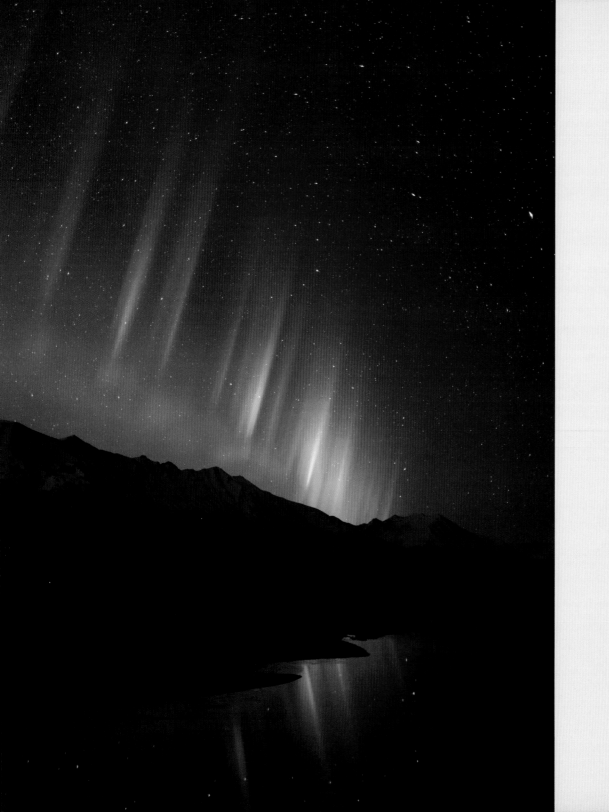

LEFT: This type of aurora starts as a vertical shaft of light near the horizon, then gets taller and brighter as new vertical shafts appear.

RIGHT: Mount Susitna, also known as Sleeping Lady, hosts a spring classic as a waning sunset and multiple arcs glow in the sky around her.

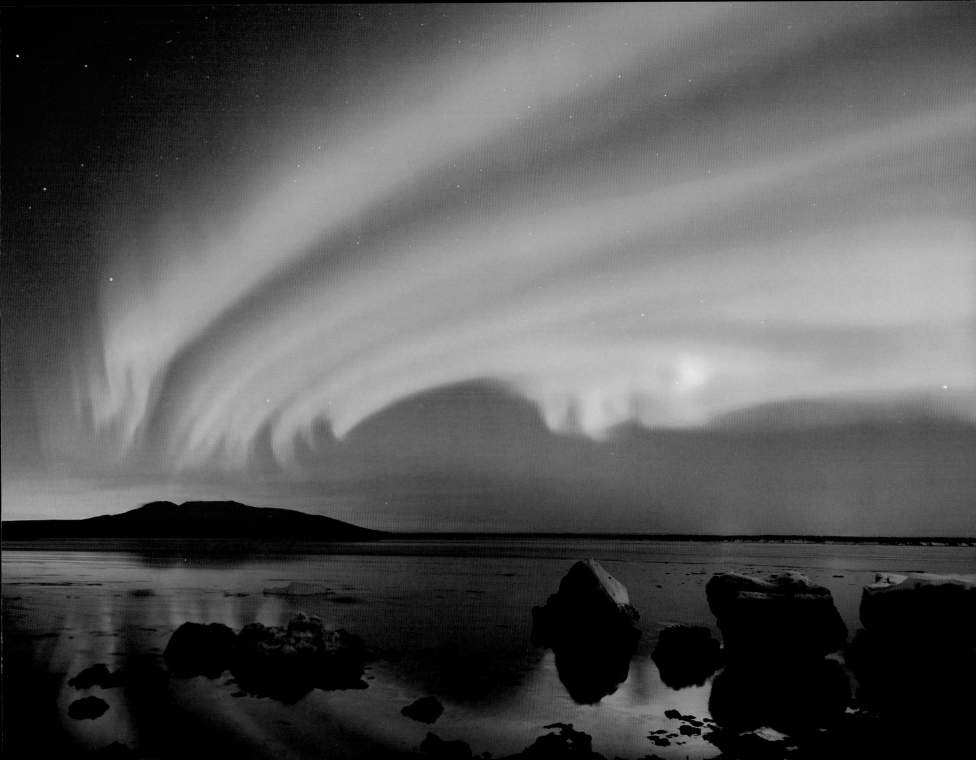

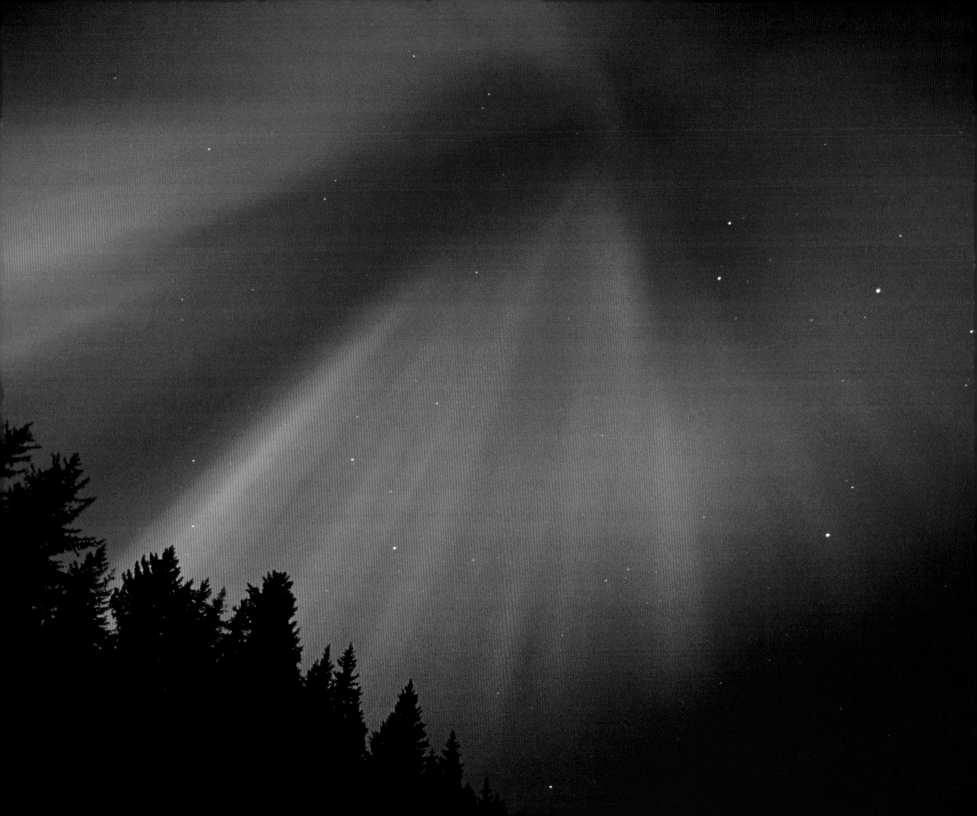

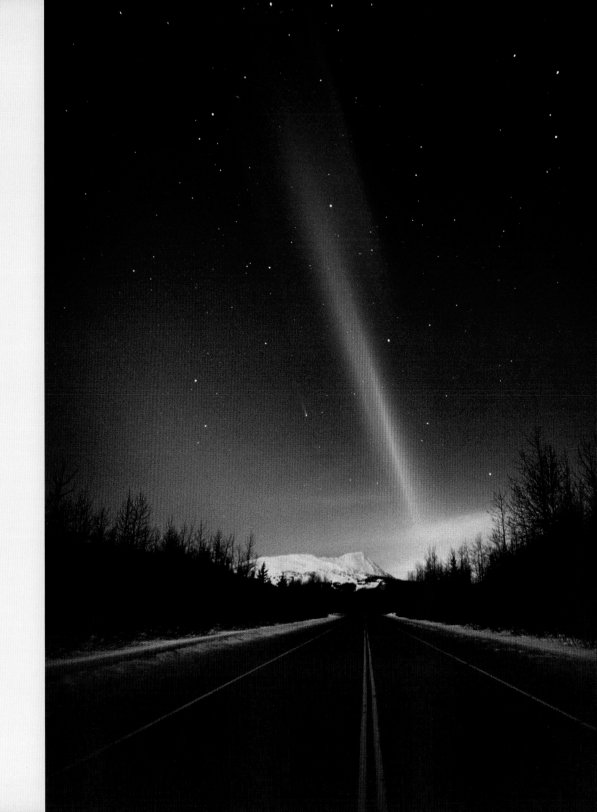

LEFT: Sunlight changes the colors of the northern lights as this example shows, when the last dark area in the morning sky produces a stellar pink corona.

RIGHT: In the spring of 2002, this towering aurora was shot over the Seward Highway near Portage. Comet Ikeya-Zhang was in the sky just to the left of the aurora.

RIGHT: The reflection on the Knik River brings to balance the composition of this photograph, shot before snow blanketed the foreground.

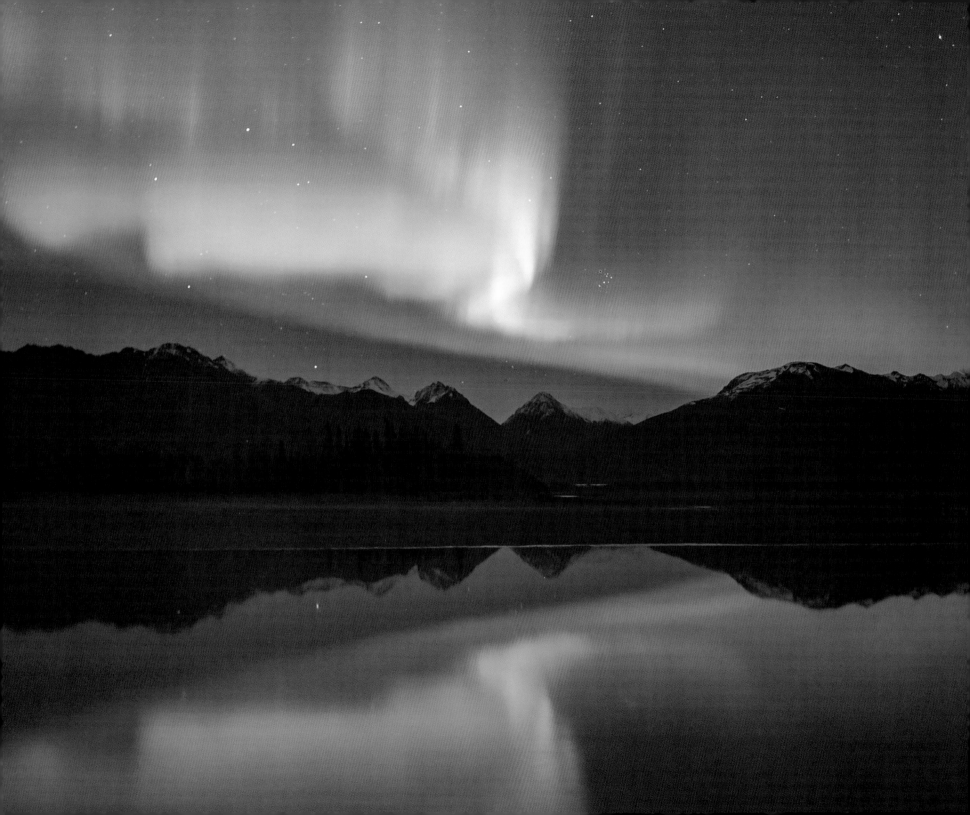

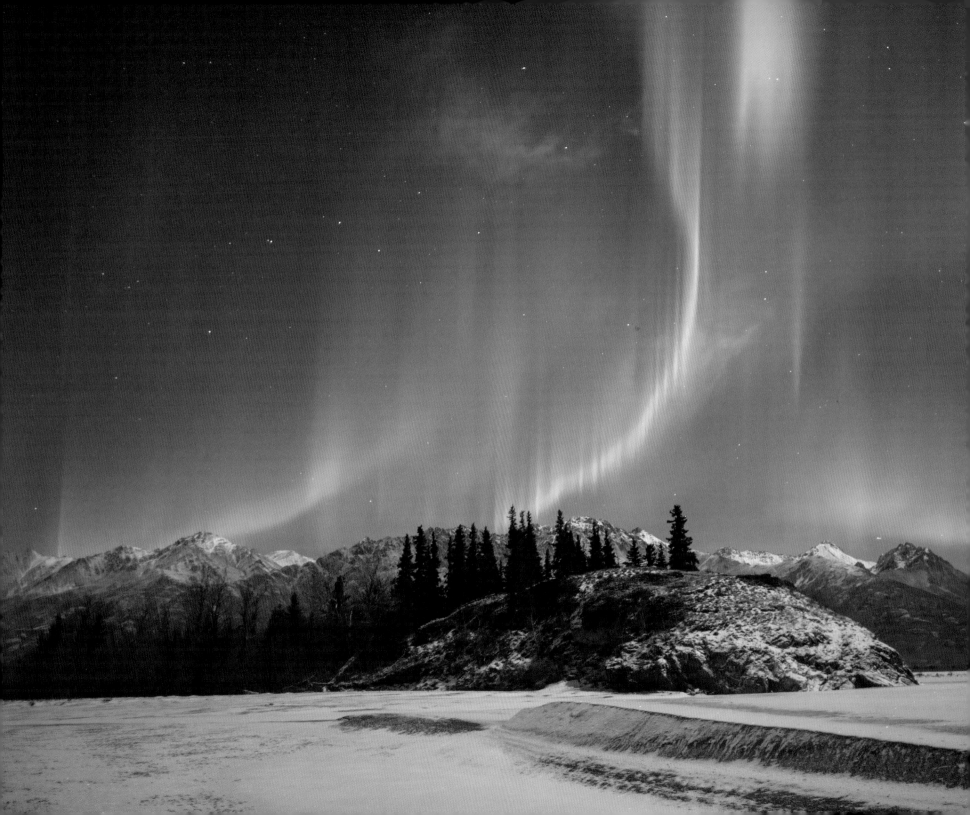

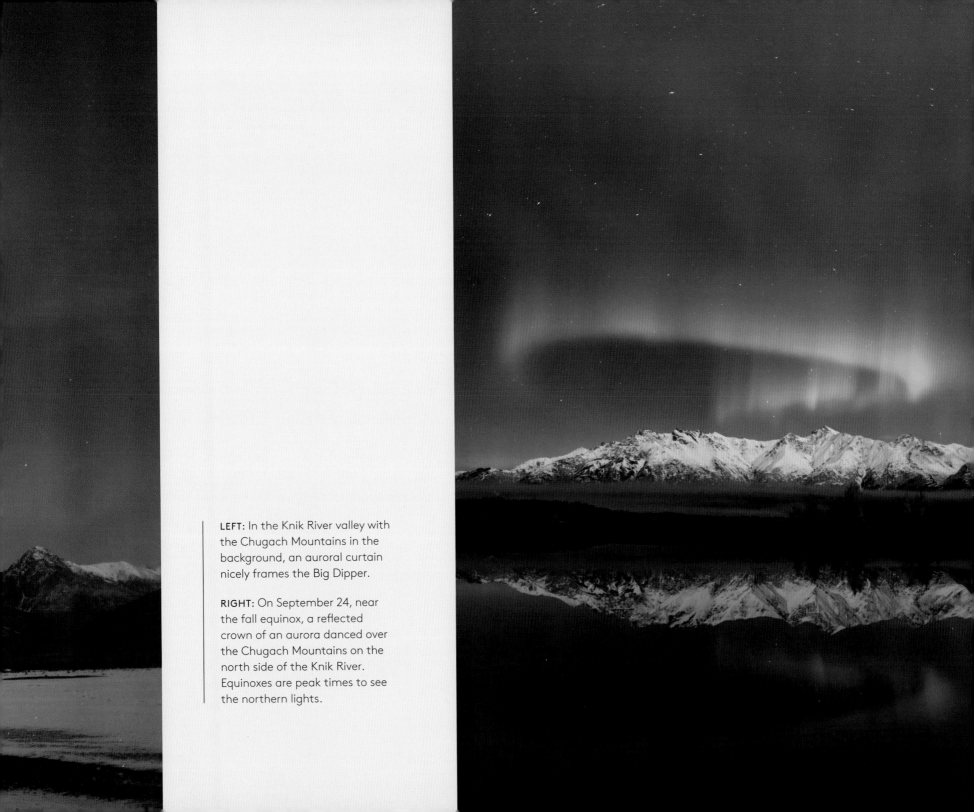

LEFT: In the Knik River valley with the Chugach Mountains in the background, an auroral curtain nicely frames the Big Dipper.

RIGHT: On September 24, near the fall equinox, a reflected crown of an aurora danced over the Chugach Mountains on the north side of the Knik River. Equinoxes are peak times to see the northern lights.

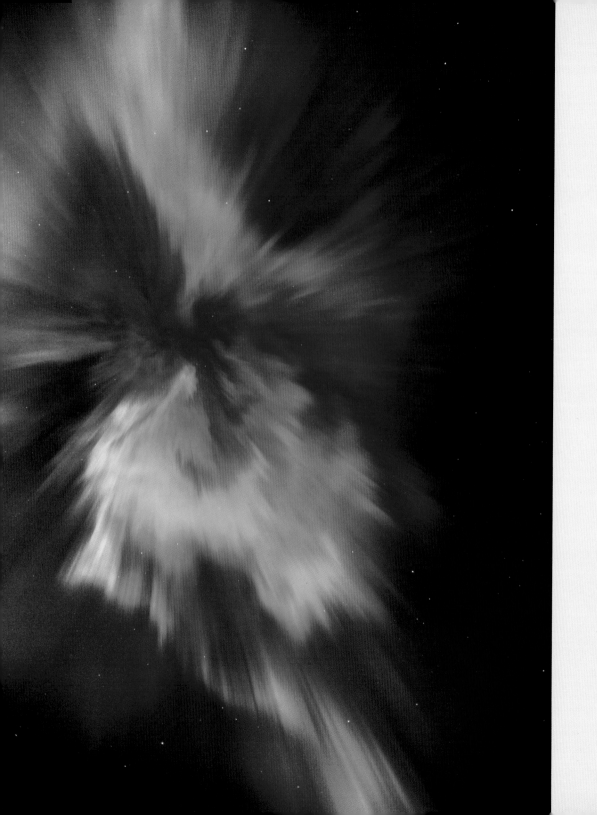

★

You cannot rob me of
free nature's grace,
You cannot shut the
windows of the sky
Through which Aurora shows
her brightening face.

—JAMES THOMSON,
"The Castle of Indolence"

LEFT: The center of a flaring corona can briefly light up the surrounding area.

RIGHT: This corona aurora is unusual because a section stayed straight as the rest swirled around.

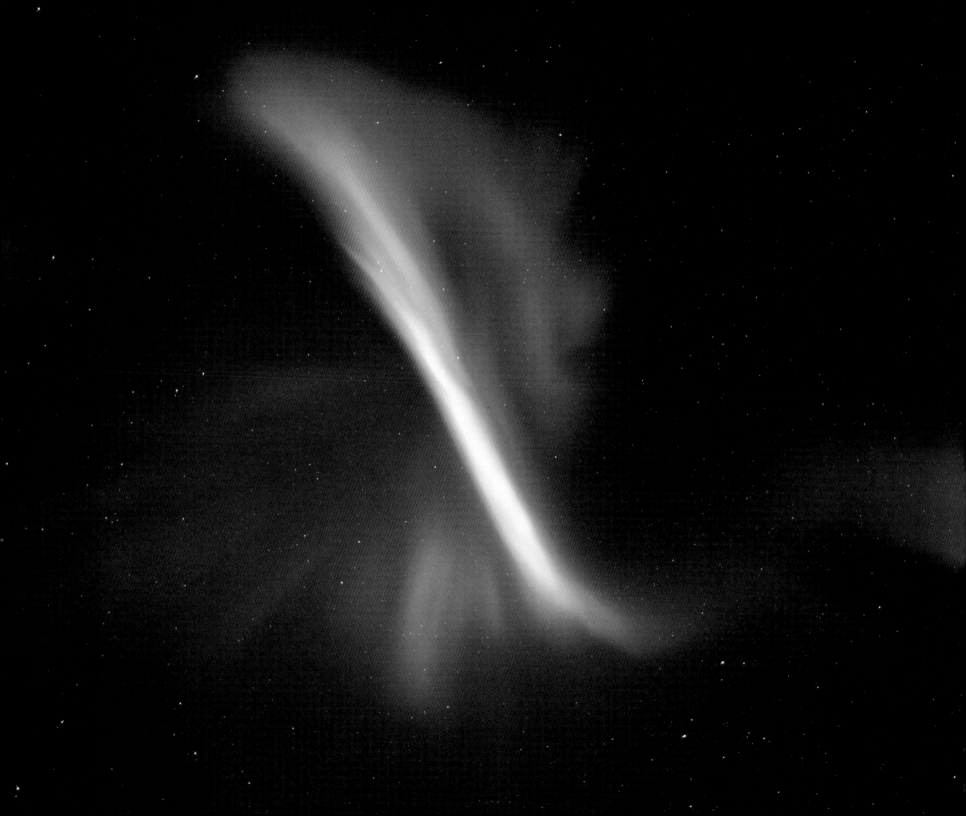

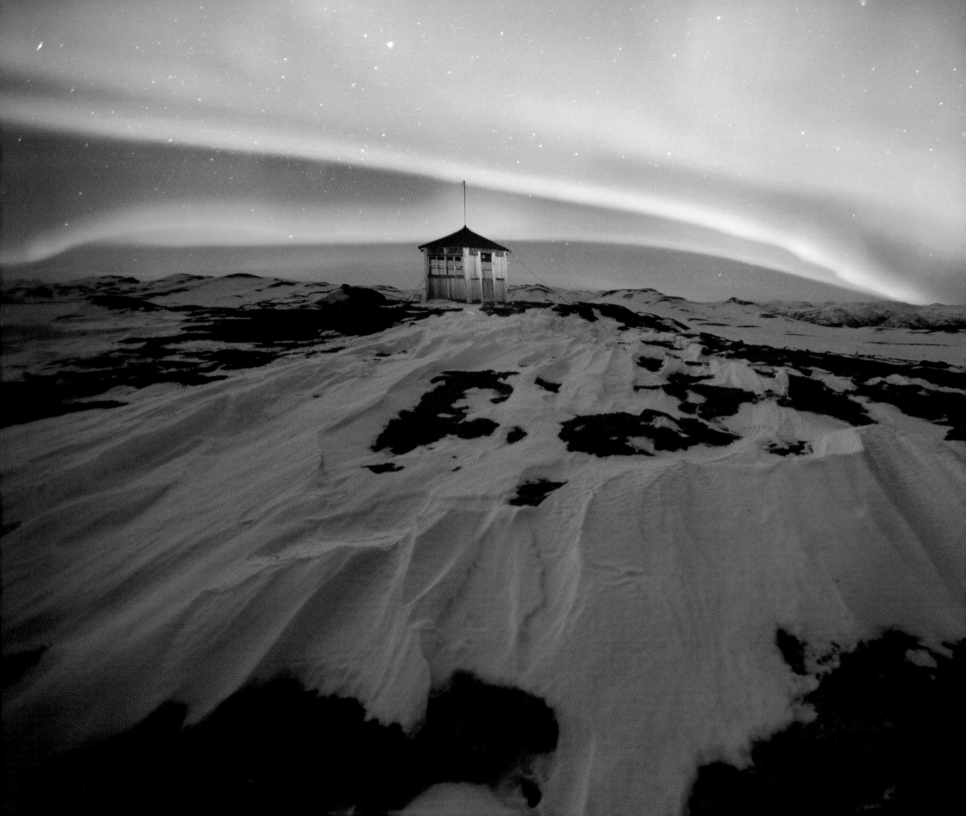

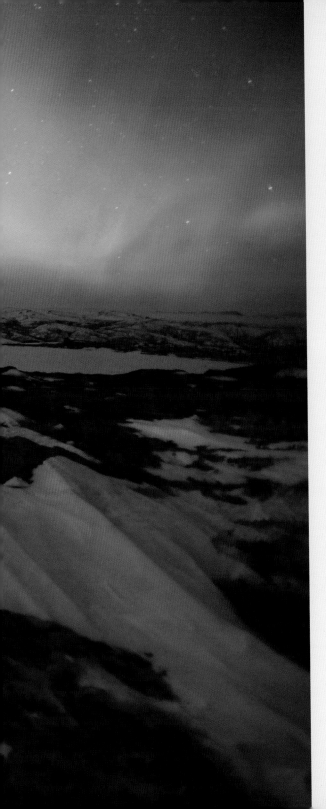

LEFT: The sculpted snow gives an account of typical weather conditions atop Curry Ridge where this mountain house provides shelter against the merciless wind.

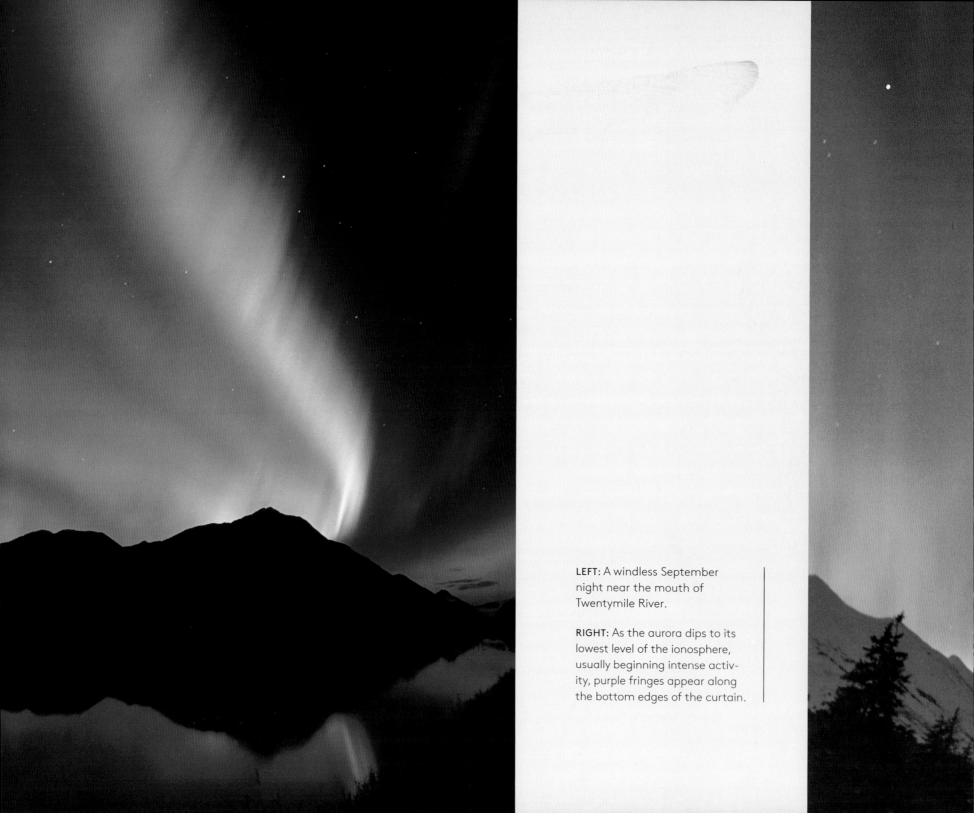

LEFT: A windless September night near the mouth of Twentymile River.

RIGHT: As the aurora dips to its lowest level of the ionosphere, usually beginning intense activity, purple fringes appear along the bottom edges of the curtain.

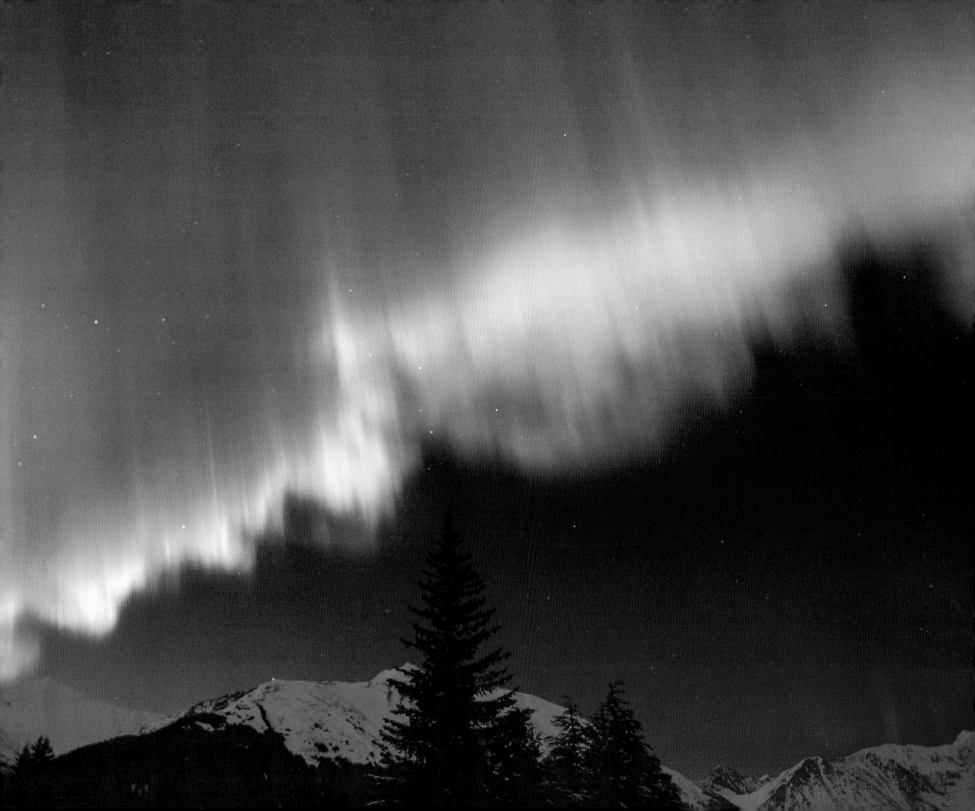

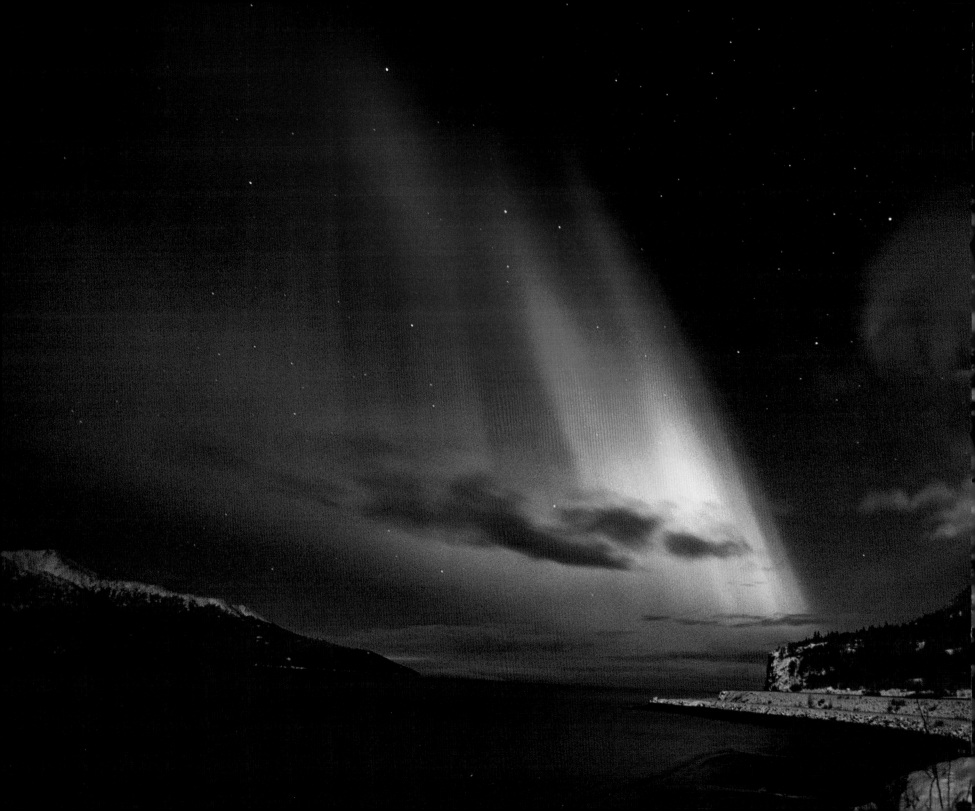

LEFT: This image was taken from the vantage point known as Rainbow, along Cook Inlet's Turnagain Arm.

RIGHT: The valley below Crow Pass glows in the soft moonlight as intense northern light activity races around the northern sky.

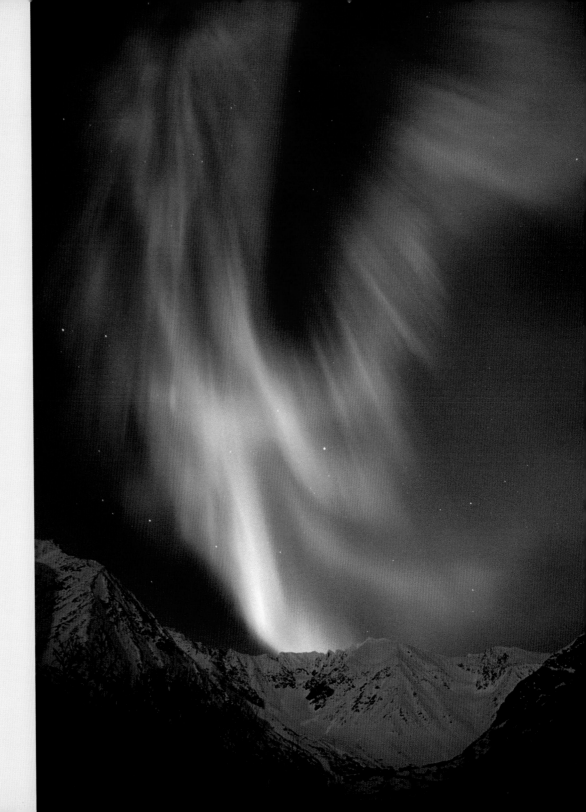

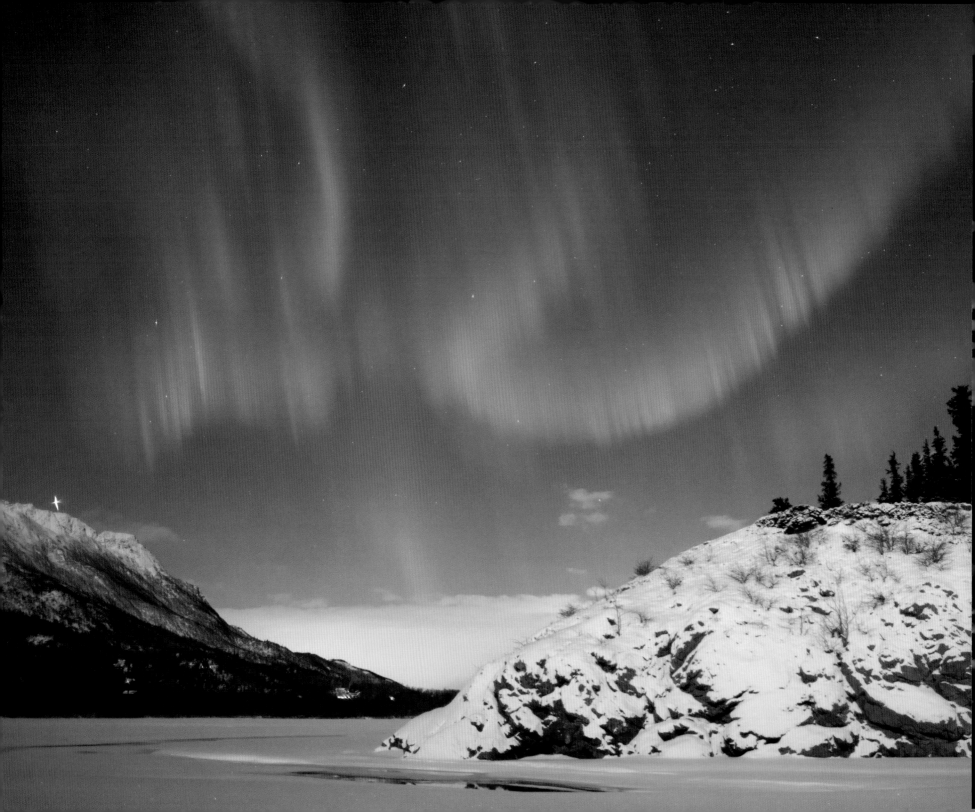

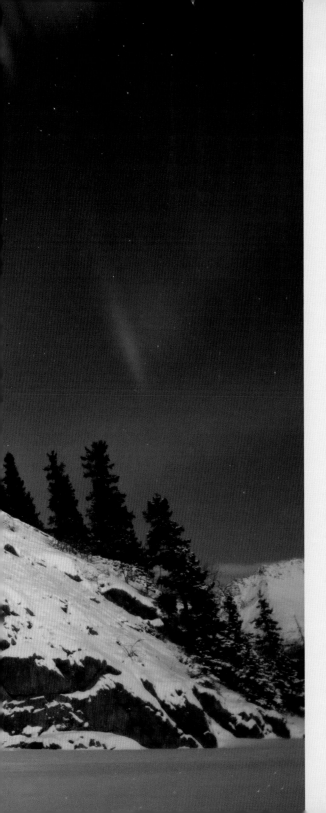

LEFT: A moonlit aurora over the Knik River valley.

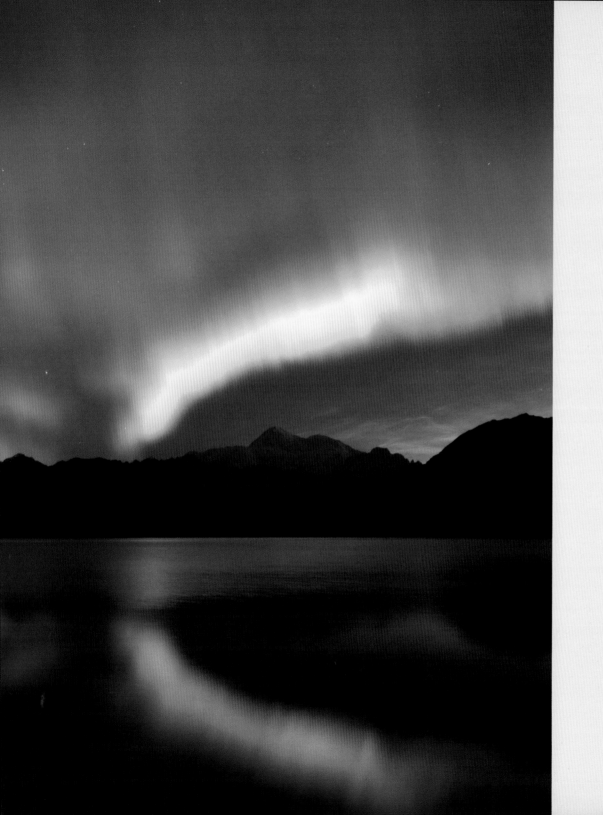

LEFT: Byers Lake with Denali in the distance in early August when Alaska is barely dark enough to see the aurora.

RIGHT: An abandoned bridge over the Knik River.

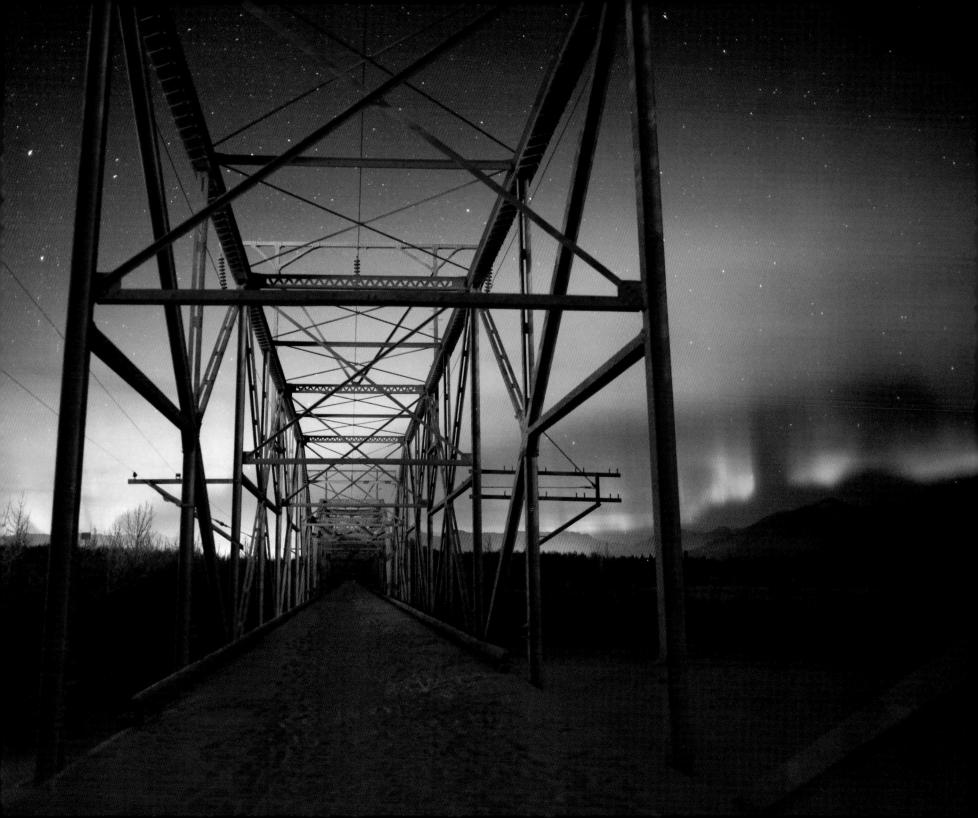

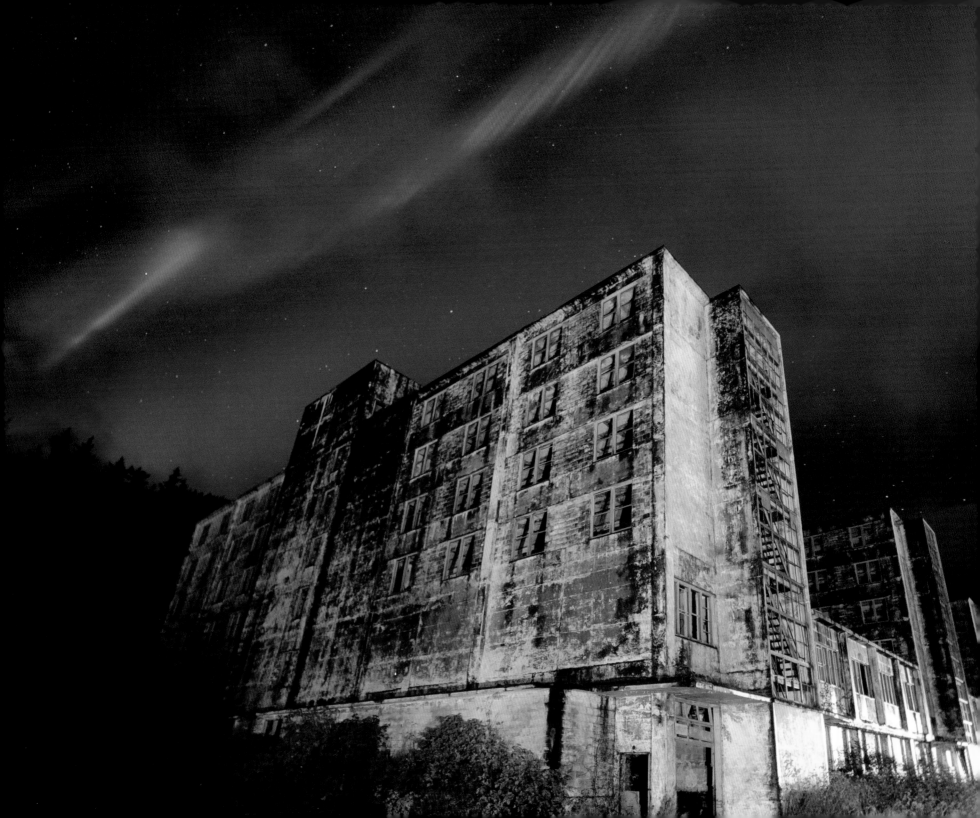

LEFT: The Buckner building made a haunting foreground on a windy October night in Whittier, Alaska.

RIGHT: A fast shutter speed is required to capture the blazing speed of these lights over Hope.

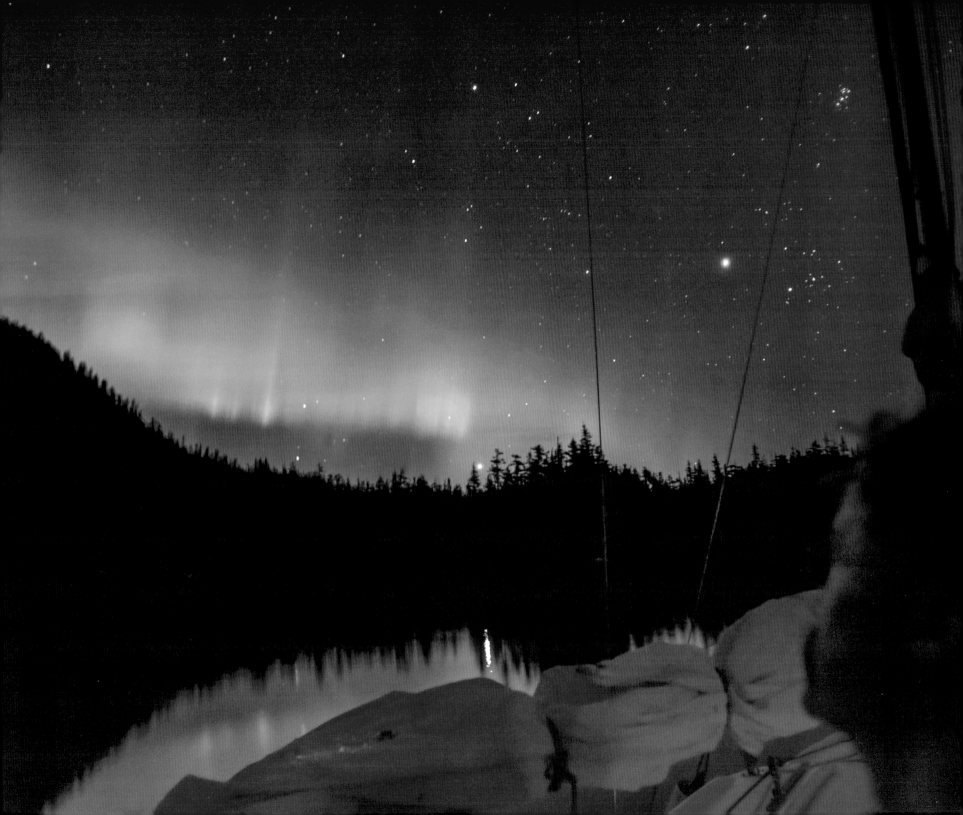

LEFT: On an August morning, an aurora reflects on Hidden Bay in Prince William Sound.

RIGHT: Because of sunlight mixing into the display, springtime auroras are often multicolored.

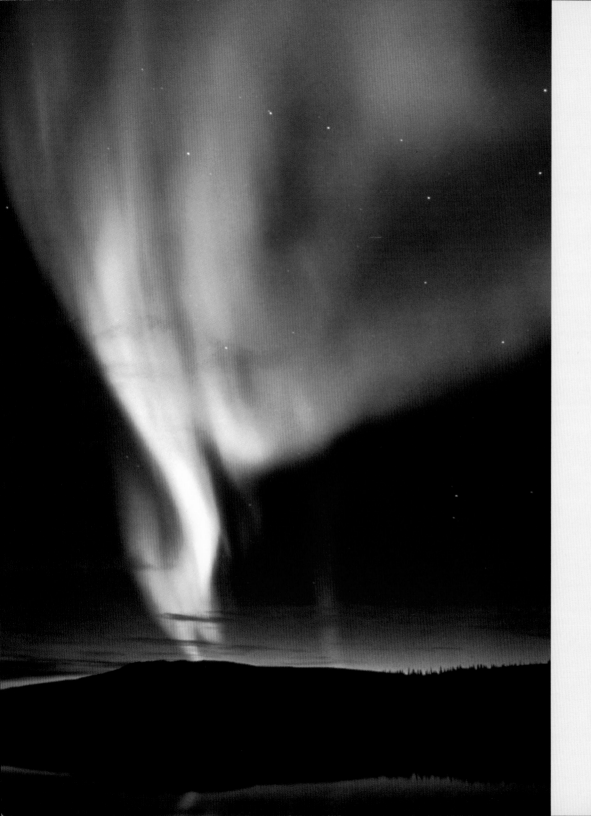

LEFT: This image was taken along the Kobuk River, near Kiana, Alaska, above the Arctic Circle.

RIGHT: This unusual pattern appeared and maintained this odd shape for an extended length of time above Twin Peaks near Palmer.

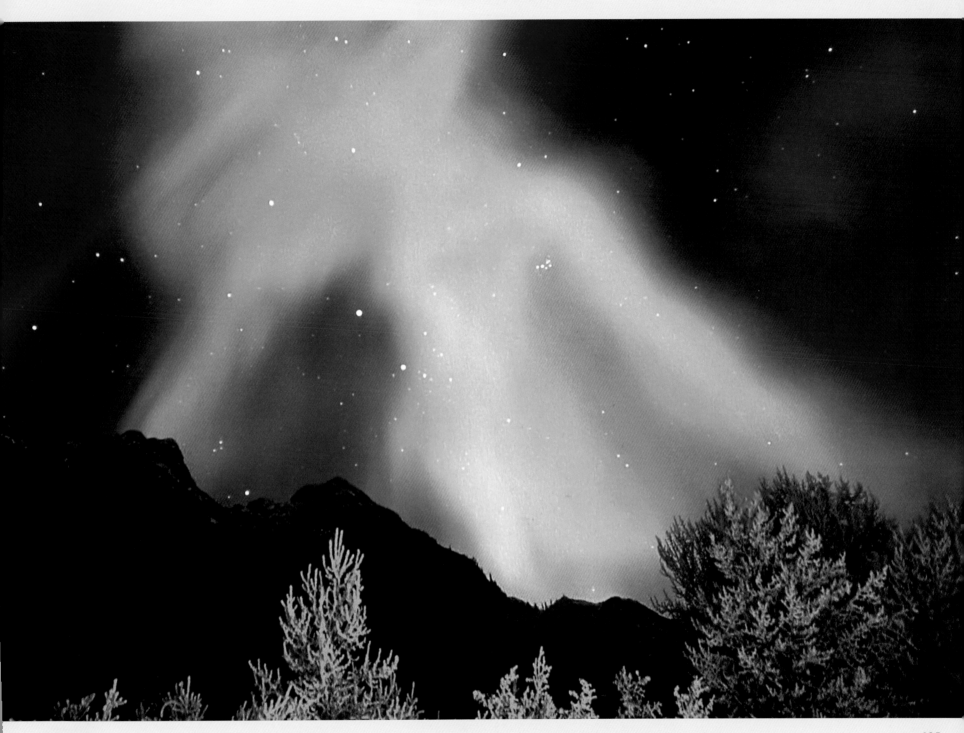

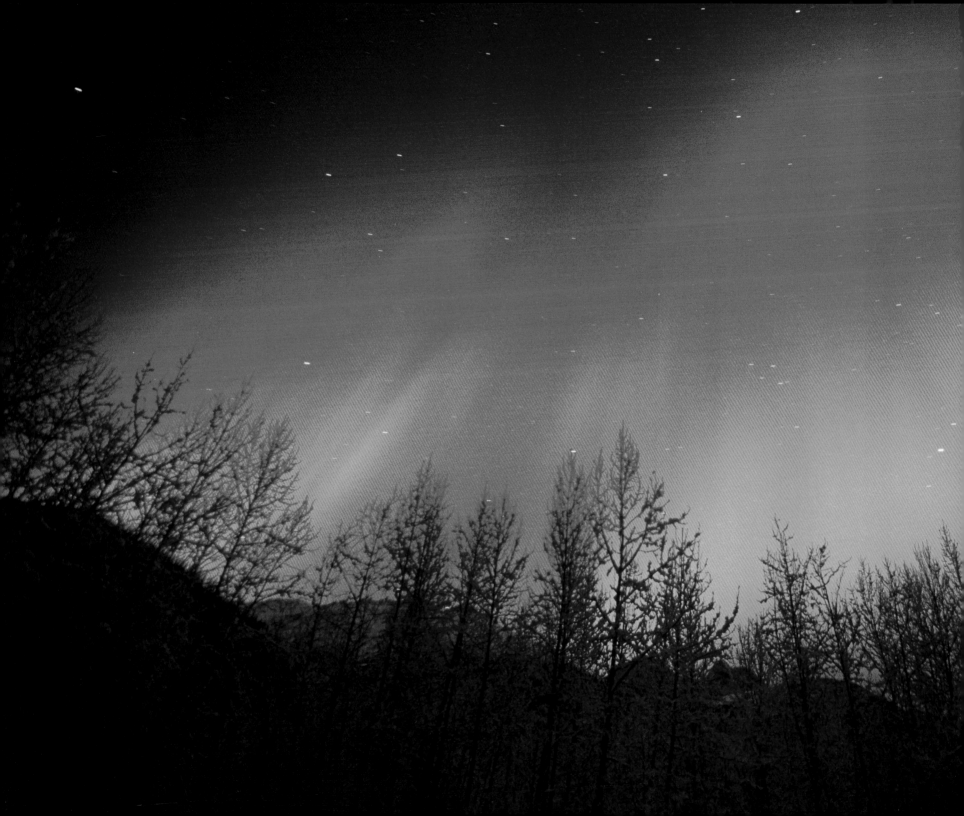

LEFT: *In the evening twilight the fog parts enough to see a crazy, bright pink aurora filling the whole south-western sky! (Images designated with an asterisk were taken in a single evening from dusk to dawn.)

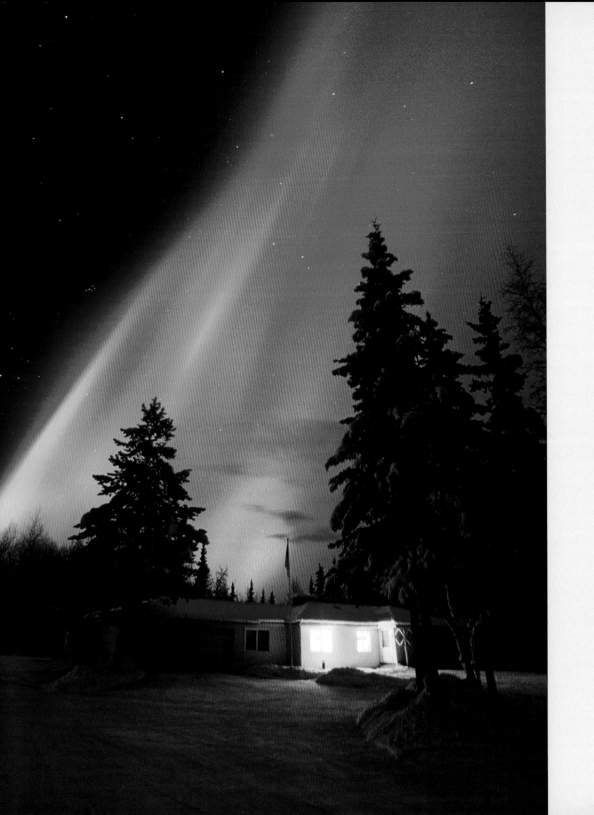

LEFT, RIGHT: *In these images, taken from the Old Glenn Highway a few miles south of Palmer, the aurora fills the sky from the southeast.

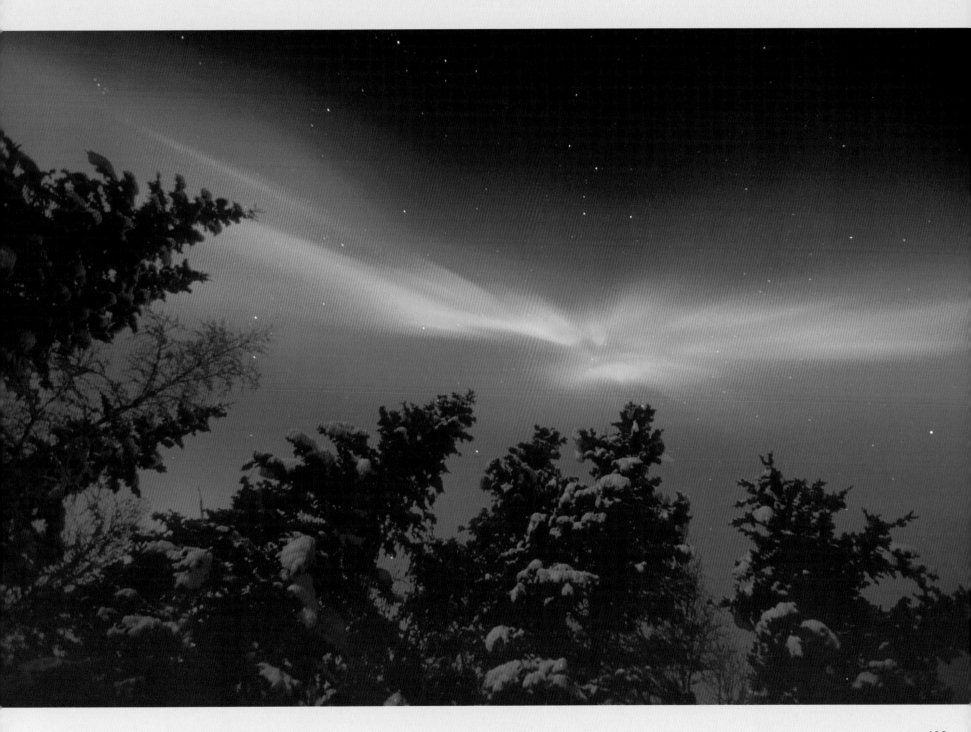

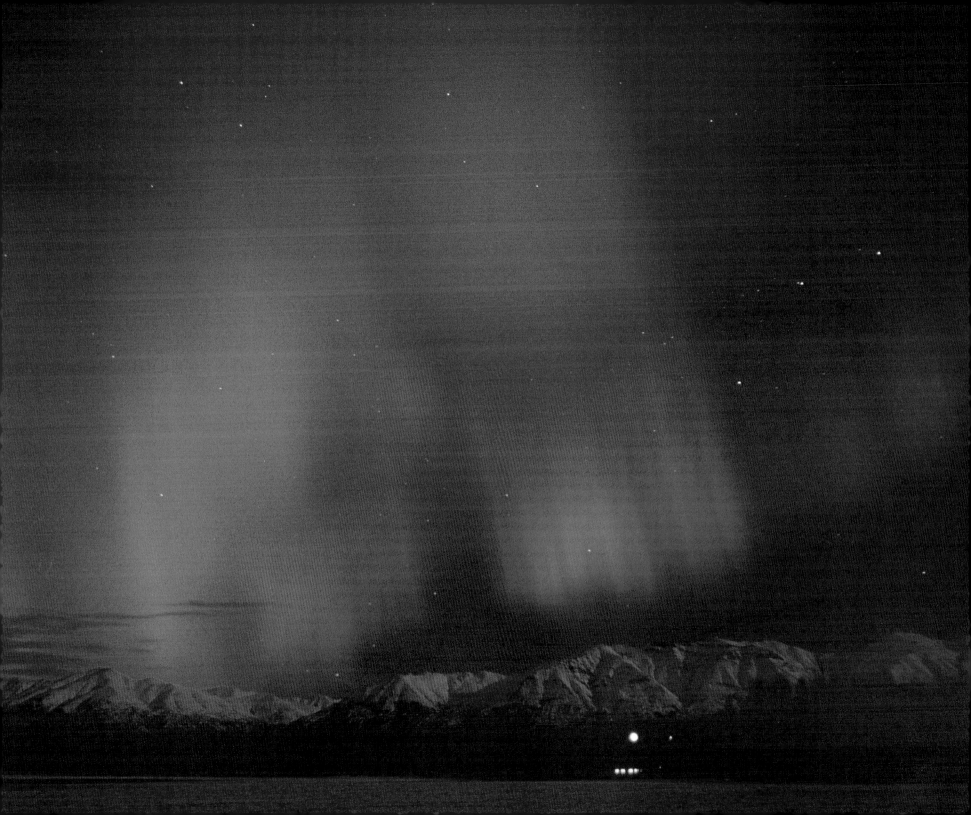

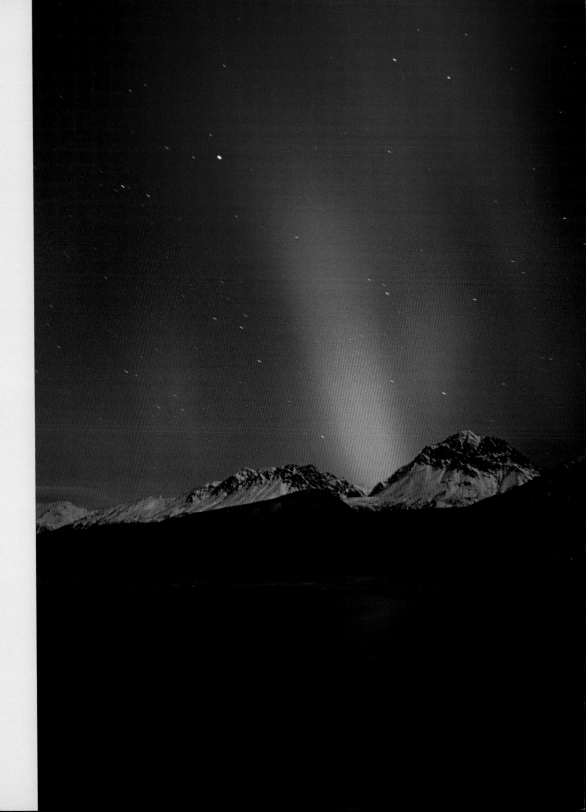

LEFT: *North of Palmer looking toward the Talkeetna Mountains.

RIGHT: *Granite Peak in the Talkeetna Mountains, north of Sutton, shot towards the northwest and reflected on the Matanuska River.

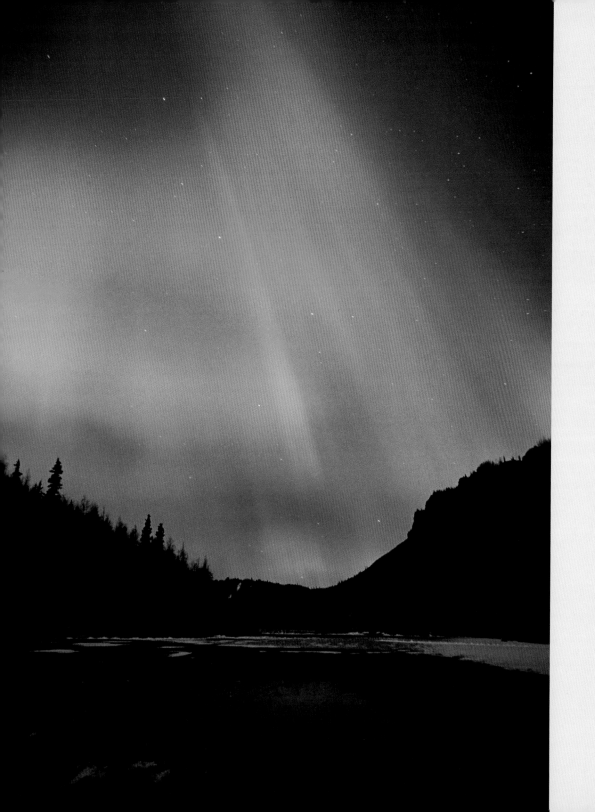

LEFT: *A colorful aurora reflected on the smooth ice of Long lake, off the Glenn Highway.

RIGHT: *The Matanuska Glacier shot from the Glenn Highway overlook at three thirty in the morning. In the moonlight and later the twilight, the colors tend to be pastels and have a much wider range than normal.

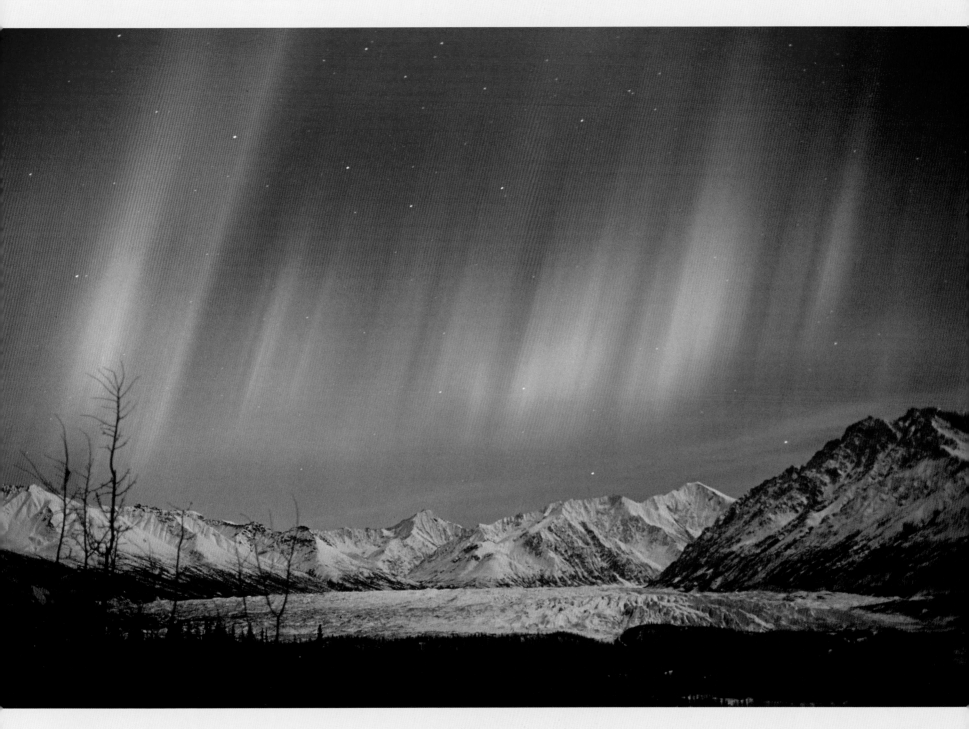

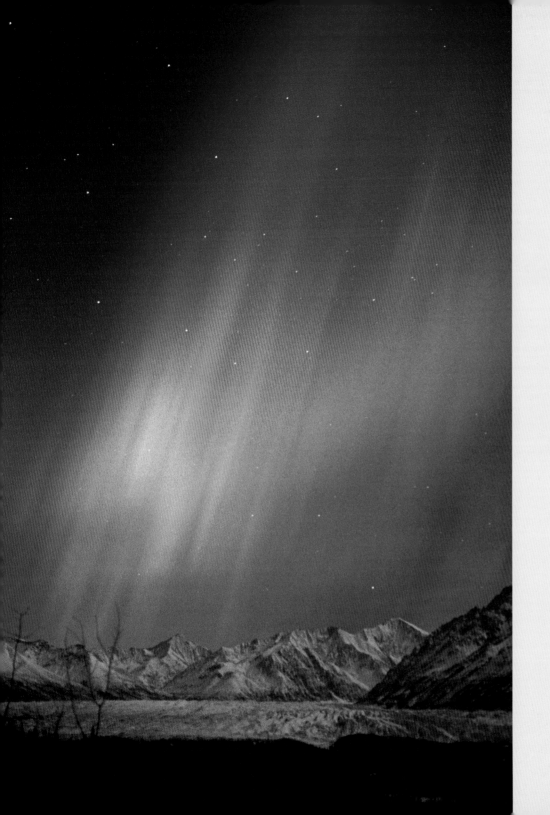

LEFT: *As dawn nears, an amazingly colorful aurora towers over the Matanuska Glacier and Chugach Mountains.

RIGHT: *The moon is actually only about a third full, but the brightness overwhelms the film, which makes it look round.

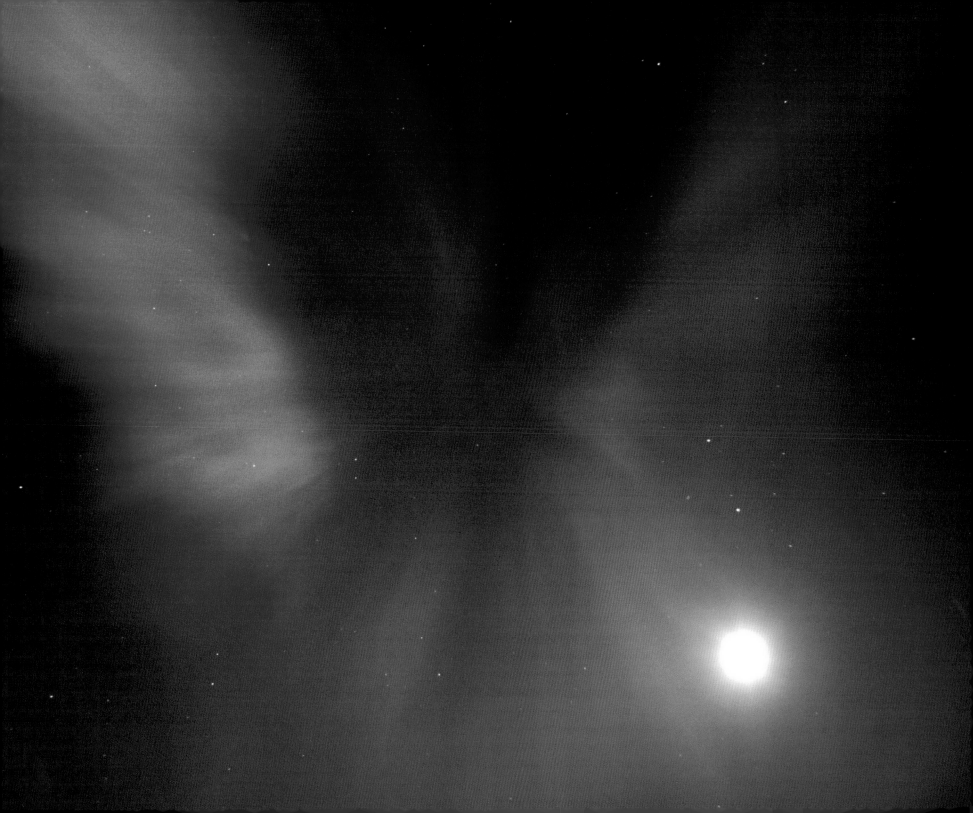

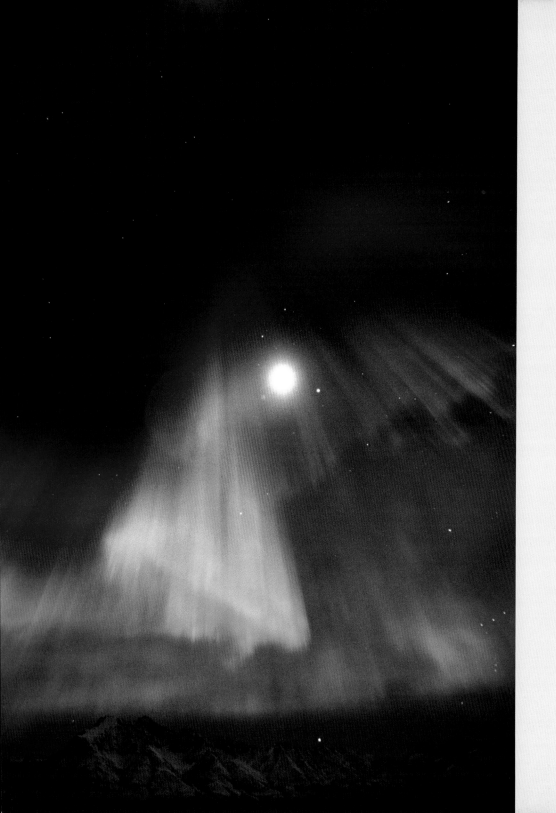

LEFT: *The Chugach Mountains shot from across the Matanuska River.

RIGHT: *The moonlight and aurora illuminate the Matanuska Glacier.

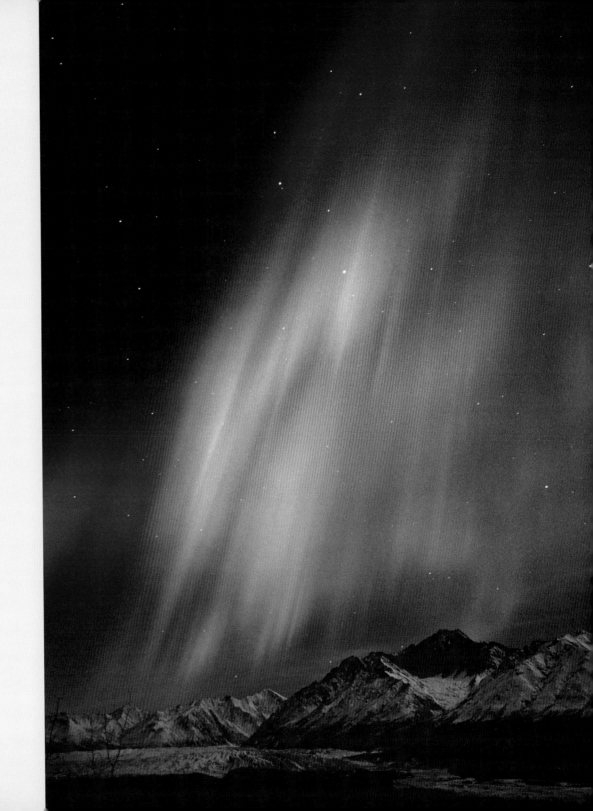

★

Beautiful and rare Aurora,
In the heavens thou art their Flora,
Night-blooming Cereus of the sky,
Rose of the amaranthine dye,
Hyacinth of purple light,
Or their Lily clad in white!

—CHRISTOPHER PEARSE CRANCH,
"To the Aurora Borealis"

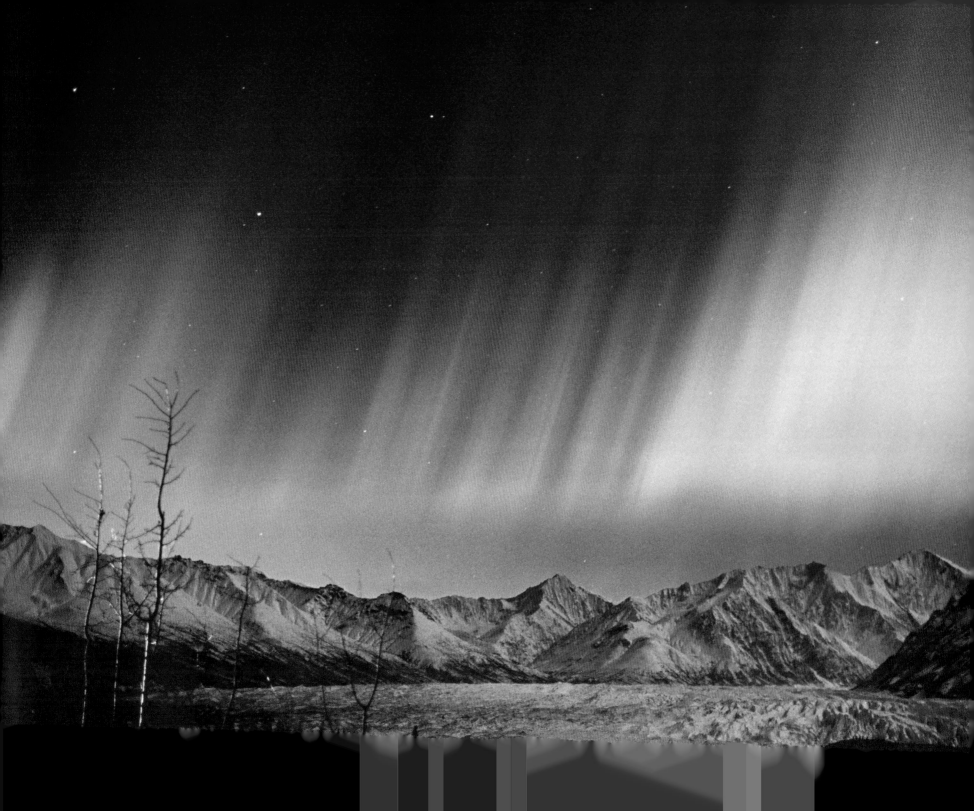

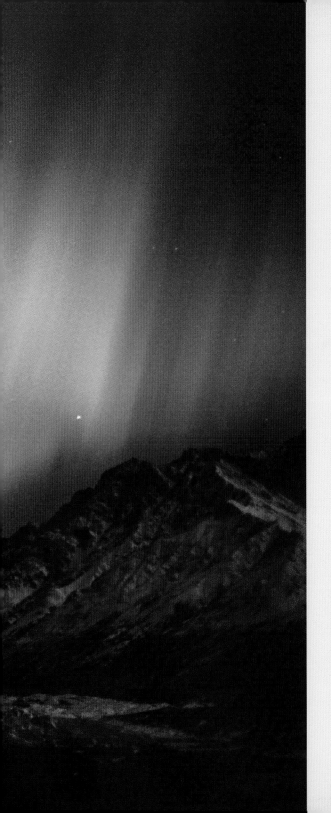

LEFT: *As dawn approaches, a glow starts to appear on the horizon. The purples and blues in this aurora are caused by the coming sunlight.

RIGHT: *Dawn brightens the sky considerably. Usually, the aurora would have long since ended for the night, but this powerful solar storm continues.

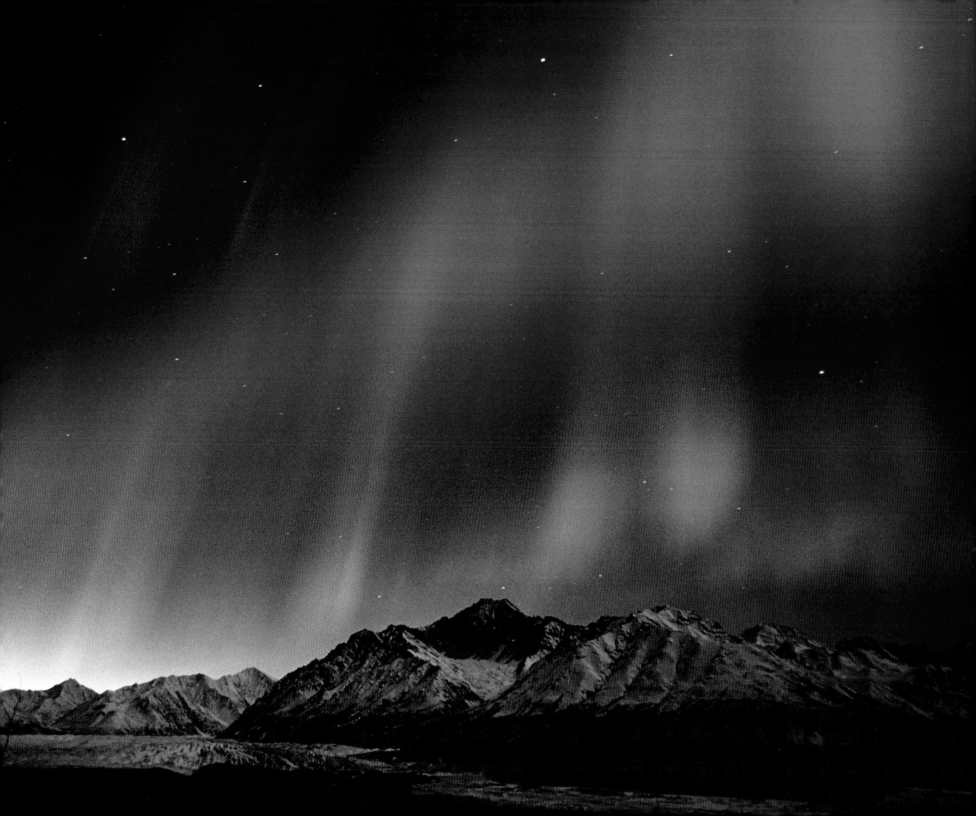

LEFT: *In the morning twilight, an intense aurora brightens the sky.

RIGHT: The shelter of an igloo makes a frigid night, with wind chill to fifty below, comfortable.

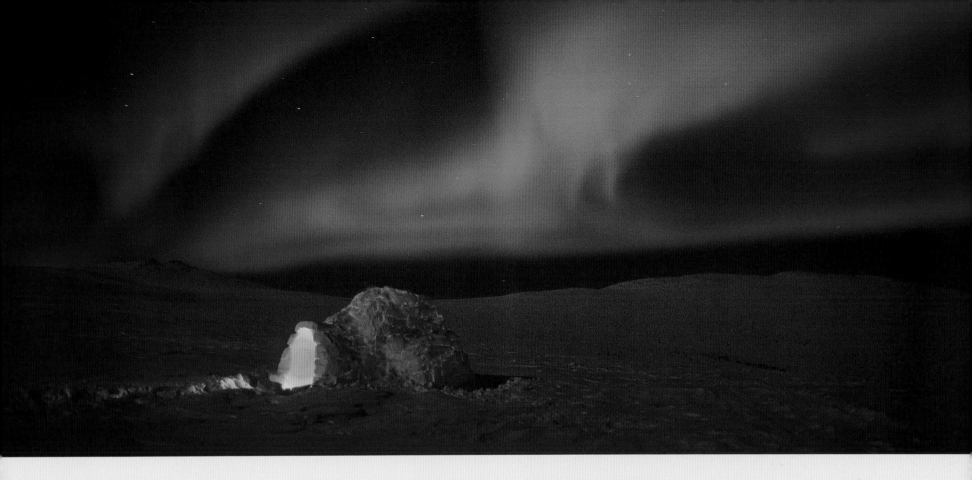

DARYL PEDERSON, an Anchorage-based nature and studio photographer, has been creating images of the northern lights for over thirty years. His aurora borealis photographs are seen worldwide, and include cover shots for countless books and magazines, including *National Geographic*.

★

CALVIN HALL is a Palmer-based photographer. His work includes time-lapse 3-D for IMAX and National Geographic movies, underwater salmon video, and commercial work for the Alaska Railroad, Google, Sam's Club, BP, and many others. He got his start photographing Alaskan nature and wildlife and is best known for his aurora photography, which he has been shooting since the '80s.

★

NED ROZELL is a journalist and adventurer. He is science writer for the Geophysical Institute at the University of Alaska, Fairbanks, and author of four books.

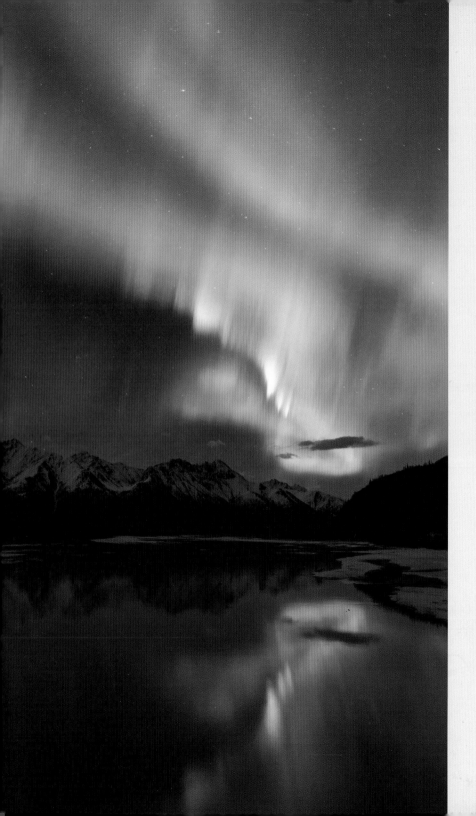

I dedicate this book to a couple outstanding men that I have known and admired my entire life. Despite being the tallest of the bunch, I will always look up to you, my brothers, Rance and Brian. —D. P.

To my dad Lee. The joy of being surrounded and astounded by God's handiwork from my earliest days outdoors with you was, and is, a great blessing. Thank you for sharing that blessing with me! —C. H

Photographs copyright © 2015 by Daryl Pederson and Calvin Hall

Text copyright © 2015 by Ned Rozell

Printed in China

SASQUATCH BOOKS with colophon is a registered trademark of Penguin Random House LLC

22 21 20 19 9 8 7 6 5 4 3

Editor: Gary Luke
Production editor: Emma Reh
Photographs: Daryl Pederson and Calvin Hall
Design: Joyce Hwang
Cover photograph: Daryl Pederson

Library of Congress Cataloging-in-Publication Data is available.

ISBN: 978-1-63217-001-9

Sasquatch Books
1904 Third Avenue, Suite 710
Seattle, WA 98101
(206) 467-4300
SasquatchBooks.com

Daryl Pederson's photographs appear on the following pages: cover, ii, iv, 3–6, 9–10, 20–21, 25, 29–30, 36, 40, 42, 45–46, 48–49, 54–56, 59–60, 62, 66, 70–71, 74–75, 81–82, 85, 88, 90, 92–95, 100–105, 123.

Calvin Hall's photographs appear on the following pages: 8, 12, 15–16, 18–19, 22, 24, 26–28, 32–34, 37, 39, 41, 43, 47, 50, 52–53, 58, 61, 64–65, 68–69, 73, 76–78, 80, 83, 86–87, 89, 96, 98–99, 106–118, 121–122, 124.